The
Restorer's Handbook
of
Sculpture

Under the direction of Madeleine Hours, chief curator of the National Museums of France, Master of Research at the National Center for Scientific Research.

The
Restorer's Handbook
of
Sculpture

Jean-Michel André

VAN NOSTRAND REINHOLD COMPANY

New York Cincinnati Toronto London Melbourne

English translation: J. A. Underwood

Copyright © 1977 by Office du Livre, Fribourg (Switzerland)

Library of Congress Catalog Card Number: 77-5413

ISBN 0-442-20237-7

Printed in Switzerland

Published in 1977 by Van Nostrand Reinhold Company
A division of Litton Educational Publishing, Inc.
450 West 33rd Street, New York, NY 10001, U.S.A.

Van Nostrand Reinhold Limited
1410 Birchmount Road, Scarborough, Ontario M1P 2E7, Canada

Van Nostrand Reinhold Australia Pty. Ltd.
17 Queen Street, Mitcham, Victoria 3132, Australia

Van Nostrand Reinhold Company Limited
Molly Millars Lane, Wokingham, Berkshire, England

16 15 14 13 12 11 10 9 8 7 6 5 4 3 2 1

Library of Congress Cataloging in Publication Data

André, Jean-Michel.

The restorer's handbook of sculpture.

Translation of Restauration des sculptures.

Bibliography

1. Sculpture – Conservation and restoration.

I. Title.

NB1199.A5213 731.4'8 77-5413

ISBN 0-442-20237-7

TABLE OF CONTENTS

INTRODUCTION

One of the most exciting moments for the art restorer is that very first encounter with the work. He is handed an unfamiliar piece, and before he has had time to place it historically the owner wants to know what he proposes to do about it and how much it will cost. Making a diagnosis, drawing up a schedule, forming a mental image of the ideal state that the piece could and should achieve in order to be true to its own particular style and essence – all this takes time. One needs to discuss the job at length, consider a number of solutions, examine the statue from all angles, test the soundness of the wood, stone, or polychromy, and consult the man on the next bench (his advice is always invaluable) before the problem begins literally to sort itself out and a definite restoration programme emerges.

A broken piece of pottery poses no aesthetic problems; one has simply to repair the effects of a clumsy moment. But a Gothic *Virgin,* eaten away by woodworm and damp, covered with coat upon coat of overpaint, amputated or on the contrary refurbished with new limbs, and no longer capable of standing on its damaged base, can be restored in a variety of ways. And whereas deinfestation and consolidation are performed as a matter of course, cleaning, paint removal, and the renewal of missing elements will be governed by what amounts to a veritable philosophy of restoration. Are we to clean the statue down to the bare wood, respect as much as possible of the original polychromy, or content ourselves with the pointillist effect of a mixture of all those coats of paint?

A history of the restoration of works of art would be most instructive, not least because the choices restorers have made in the past as well as the excesses of which they have sometimes been guilty surely have a great deal to tell us about the way in which men down the ages have looked at things. Who today, equipped with our modern vision of Egyptian art, can understand those hair-raising nineteenth-century restorations? Yet the restorer concerned was not without talent, shared his vision of Egypt with Verdi, Hegel, and Théophile Gautier, and sincerely believed he was doing an archaeologically honest job (ill. 1). Would we hand even the least little archeological find over to a modern

sculptor for him to complete and bring into line with today's taste, as Bouchardon did with the *Venus of Arles?*

What is it that prompts a restorer to choose one method rather than another, to treat a classical marble differently from a sixteenth-century wooden bust, an eighteenth-century plaster from a Gandhāra stucco, a polychrome *Virgin* from a Japanese carving? Why did that nineteenth-century restorer renew more than half of this statue, and how is it that we today are able to appreciate the original fragment as it is?

For one thing, the restorer's choice is guided by the evolution of taste as regards the ageing of works of art. A piece of sculpture, whether of wood, stone, or plaster, begins to age the minute it leaves its creator's hands; it suffers wear, collects dirt, loses its colour, or becomes covered with lichens. As far as sculpture is concerned, it is only a small number of relatively recent works that we know in their pristine state; we know nothing about the original outer skin of the statues that adorn our cathedral portals, and only a few residual flecks of colour tell us that all those Greek marbles were originally painted. Our taste has been formed through contact with eroded, fragmentary, patinated works; our adolescent sensibilities are shaped by the idea of an armless *Venus of Milo,* by flaking polychrome statues, golden ivories, and dirty plaster. Our adult minds remain to some extent in thrall to this liking for the imperfect, the incomplete, the ill-defined, finding in it that mystery which philosophers consider essential to richness of perception. The restorer cannot help being aware of this universal process of ageing and of the evolution of taste.

Occasionally, however, the phenomenon is partially reversed, and the restorer may have quite a bit to do with it. All it needs is for a major collector of terracottas to install a particularly smoky fire-place in his home; his collection becomes impossibly soiled; he discovers that a general clean-up has the effect of a resurrection, and the fashion for patinated terracottas becomes a thing of the past. Or a Minister of Cultural Affairs decides to clean the monuments of Paris, and suddenly everybody likes them clean. A new generation is shaping its sensibilities before classical bronzes stripped of their patina, before white cathedral portals, and before terracottas that look like new.

Another factor influencing our ideas of restoration is the way in which we approach a work of art. Is a polychrome *Virgin* a cult object or a valuable art object? As an object of worship it will be repainted along with the sacristy and possibly burned when the vestments catch fire; once it finds its way into an antique shop, it sheds its religious significance, and the restorer seeks to rediscover, beneath the badigeon, the volumes and colour of the original state. What did a Gothic cathedral mean to Victor Hugo? It meant an atmosphere of dark mystery and meditation; it offered him a marvellous hagiography that it was logical to reconstitute as new, as Viollet-le-Duc in fact did. The modern mind is struck above all by the extraordinarily graphic quality of Gothic architecture; the pedagogic aspect of the portals has lost its importance, and one would not, for example, reconstitute the façade of Notre-Dame.

Finally, science and scholarship have revolutionized the very spirit of restoration in the twentieth century. Technological progress, advances in the field of art history, and the mass of documents and reproductions available to the modern museologist

are such that we could reconstitute as much as half of a statue without errors of style. Yet our knowledge seems to have made us hesitant to make any reconstitutions at all, or rather to have put us in a position to achieve them by the exercise of imagination alone. Science would appear to have steered restoration in the direction of an immense purity, a determination to do no more than salvage, seeking to recover the truth of the object concerned without trying to return it to an assumed original state, in other words doing nothing that would involve guess-work and invention.

This most commendable attitude can be taken too far, however, as when it rules out any kind of sensitivity in favour of an ice-cold objectivity: patina must invariably be removed; all classical bronzes must be cleaned; what we are after is the truth (which no one knows), disregarding any notion of charm; as a witness to a vanished civilization, the object must provide us, after "treatment", with a maximum of information. In fact, an archeologist once said, "What matters as far as we are concerned is that the object can be photographed and card-indexed; we couldn't care less about the lichens and the pink dust accentuating the carving of the hair." Science and scholarship are a positive factor when they tell the restorer to do as little as possible, simply saving the object from destruction. They are negative when, rejecting the concept of the masterpiece and expressing contempt for aesthetic emotion, they rank a Khmer statue with an object of merely ethnographic interest.

The restorer may shake his head ruefully at this point when he thinks of what the trade obliges him to do. Unfortunately this is often far removed from any idea of purity and authenticity. A Christ figure is a cult object, but without its arms it becomes an art object, so these are ruthlessly amputated in order to sell it. A Roman sarcophagus decorated with a tedious battle scene is broken up and the individual fragments sold all over the world to collectors of classical fragments. A Roman *Venus* unlucky enough to have preserved one of its legs has this chopped off above the knee to turn it into a Cnidian *Venus*. An African carving is tampered with in order to alter its tribal attribution to commercial advantage. The list of harrowing examples is endless.

In spite of these abuses, however, which degrade the restorer to the level of a forger, the art trade is not to be condemned out of hand. Faced with the coldly objective attitude of the scientific fraternity, the antique dealer heeds the taste of his clientele and is inclined to respect what time has added to the object. Even if a sculpture's patina and charm are subjective elements, usually reflecting social values (patina being a mark of age and consequently of rarity, it testifies to both the good taste and the social standing of the owner of the piece), respecting them calls for a flexible, non-systematic approach to restoration, an approach that treats every case on its merits and rejects blanket solutions. On the other hand there is no denying that the increasing scarcity of art objects, by obliging dealers to create fashions, has meant that they have rescued many objects from oblivion and eventual destruction. The art of 1900 and 1925, having been made fashionable again by the trade, is at last finding its way into our museums. And would it be going too far to suggest that certain ecclesiastical statues have been saved only by having been burgled?

In his dealings with the antique trade the restorer

must reject an *après moi le déluge* attitude. No matter what interests are at stake, he must always make his work reversible. This, when all is said and done, is the only absolute, the only law by which the restorer must abide. He can reconstitute a nose, even making his repair invisible to the point of deception; that is fine, particularly if as a result the face comes alive again. But only on condition that, if the nose is removed a century hence as being stylistically incorrect, the re-restorer shall not find in its place two dowel holes in one of those dreadful artificially flattened surfaces. Preferring dirt to cleanness no doubt indicates a greater attachment to the outward sign of an ancient pedigree than to the truth of a Caffieri bust, but today's omission can be made good tomorrow, whereas one will never be able to replace the azurite and malachite on a classical bronze that has been cleaned with chemicals. This is the key to the restorer's role vis-à-vis the objects he treats: not only must he observe the dictates of technical prudence; he also has a duty to impose his own integrity and his own vision of his craft, rejecting everything that seems to him detrimental to the object in question. His experience and the physical contact that he has with works of art are his authority for so doing.

Whatever the restorer's attitude, whether he works in a laboratory or in the back room of an antique shop, regardless of his ethical standards, he must know in advance what he wants to achieve and not let himself be swayed by events. Picasso once said, "I'm impatient to start work to see what will come out." For the restorer this will not do at all. He does not blindly set about cleaning a statue with the intention of stopping when he is satisfied with the result. That moment is unlikely to arrive. The restorer must have a very firm idea of what he wants before he starts, a positively Aristotelian idea of the proper state of a piece of sculpture: the ideal is a reality, and I shall find it. The restorer has a personal but very definite idea of the amount of dirt an antique plaster can stand, of the true nature of an ancient polychrome, of the way its colours should vibrate, and of their ideal brilliance. This imaginative anticipation of the end result is the *summa* of the restorer's craft, experience, integrity and good taste.

The good restorer does the minimum, even when this involves more effort than would a less restrained approach. He is a little like an *haute école* horse executing its graceful figures – a dancer rather than a cart-horse. The modern restorer no longer daubs a statue to mask its imperfections or conceal repairs; often he will content himself with making them inoffensive. His retouching is transparent, light, luminous, and confined almost exclusively to the renewed portion. He will have no hesitation about leaving a glued crack visible if it does not disturb the sculpture's rhythm. He will carefully weigh up, every time, the gravity of a particular intervention and what the object will gain by it. Often he will be brought an attractive piece that the customer hopes can be made even more attractive, in which case he may say quite candidly, "No one has ever touched this sculpture; tomorrow someone will have touched it, and however skilful the workmanship it will show, so let's leave it alone!"

Finally, the restorer will have a sense of balance and harmony. Harmony is not an easy thing to define in relation to restoration. An estimate worded "Cleaning of plaster – repairs, overall harmonization" was sent back on the grounds that it was insufficiently

clear; would they please define the term. One definition maliciously put forward was "a mealy-mouthed way of saying that the whole thing will be repainted". But that would be a cheap kind of harmony. The restorer's skill consists in achieving a harmony of contrasts. When he has finished cleaning he will stand back and look at the statue through half-closed eyes in order to see it as a whole, as a single perception, registering the "wrong notes" that call for correction. To do this he must have completely assimilated a sculpture's rhythms, spirit and style. He will camouflage one stain because it offends and leave another; he will, as it were, harness colour to volume, respecting the variety of shades present and the vibrations of the material.

Besides his technical skills as painter, sculptor, chemist and physicist the restorer must be in possession of these finer qualities: an aesthetic lightness of touch, a feeling for harmony, and a scrupulous moral sense. Thus equipped, he will find his craft leads him unerringly, like Ariadne's thread, towards an understanding of the work of art. He will spend several hours, sometimes several days with the piece of sculpture that he is about to resuscitate; he will make it to some extent his own, and if he does not let himself be carried away by the purely technical side of the problem, he will come to understand and love the piece more deeply through working on it than would be possible in any other way.

This book makes no claim to reflect official international practice. I shall take a look at the state of modern knowledge, research and technology with regard to wood and stone, but as far as actual techniques of restoration are concerned I propose to discuss only those I use myself. All restorers have the same glues, the same varnishes, the same simple set of tools. The important things are the eye and the hand that guide and hold them, and the patience and love that govern their application.

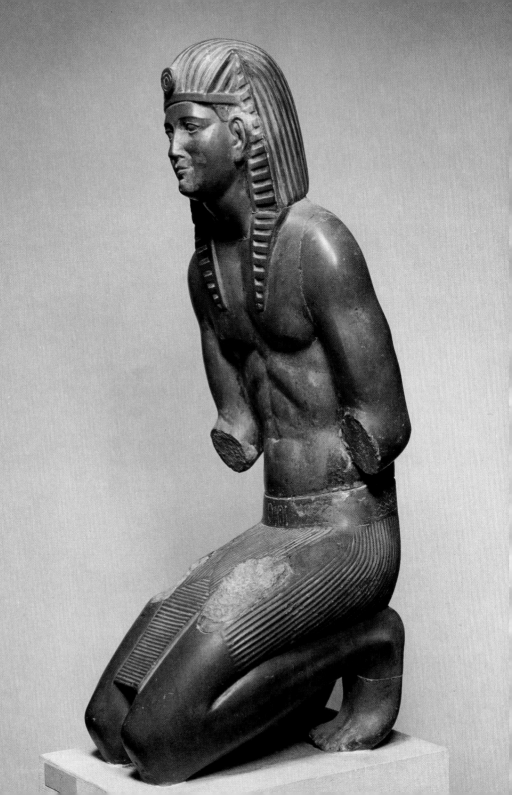

STONE SCULPTURE

Diseases of stone

Stone has always been a favourite material for masterpieces, a symbol of solidity and permanence that our industrial age, however, seems determined to belie. For just as we know little or nothing of the painting of ancient Greece, the centuries to come stand a good chance of never experiencing the splendour of our cathedral portals; their wonderful gospel in stone becomes less and less distinct each year as the robes forfeit a little more of the rigour and delicacy of their chiselling and the faces lose their expressions for ever.

Sculpture in stone includes of course not only the works that people have seen fit to put under cover or that were carved for the drawing-room in the first place; by far the greater part of the world's sculptural heritage, from the bas-reliefs of Angkor Vat to the Royal Portal of Chartres (ills. 5 and 6), stands in the open air where, exposed to fluctuations of temperature and relative humidity, the erosive action of wind and rain, and the onslaught of industrial salts and bacteria, it is in danger of perishing of what are commonly known as the diseases of stone.

Today this process of deterioration is accelerating dangerously. There would be nothing left of the Moissac statues (ills. 10 and 11) if they had been deteriorating since the twelfth century at the rate at which they are deteriorating now. The extreme western tip of the Asian land mass that is our continent of Europe, an area that man's genius has covered with sculptured monuments over the last thousand years, is deeply concerned about this drastic process and anxious to understand it in order to do something about it. A chapter on the restoration of stone statuary cannot confine itself to questions of renovation, repair, cleaning and colour-matching; it must also deal with the major problem of the diseases of stone.

It is after all a fairly simple matter to take a decayed piece of wood-carving, consolidate it, glue it together again, give it an "acceptable" appearance in accordance with current taste, and stick it in a museum, almost as one might preserve a piece of fruit. But unless you go about it as has been done with the Catalonian frescoes, systematically replacing the originals with copies, you cannot "preserve" the portal of a cathedral; it will continue to be exposed to wind, rain and pollution.

The problems posed by monumental sculpture of this kind lie well beyond the competence of the individual restorer; they lie, as indeed they should, at the international level, where they call for a mammoth co-ordination of knowledge in the fields of architecture, chemistry, physics, biology, climatology and geology.

Before going on to deal with restoration techniques proper, let us try and take stock of the pathology of stone and look at the kinds of treatment designed to conserve *in situ* the works most representative of the genius of our race.

1
◀ A nineteenth-century restorer has retouched more than half of this Egyptian statue.

2
Alveolation in some limestone exposed to rising damp.

3
Flaking in sandstone following the lie of the stone.

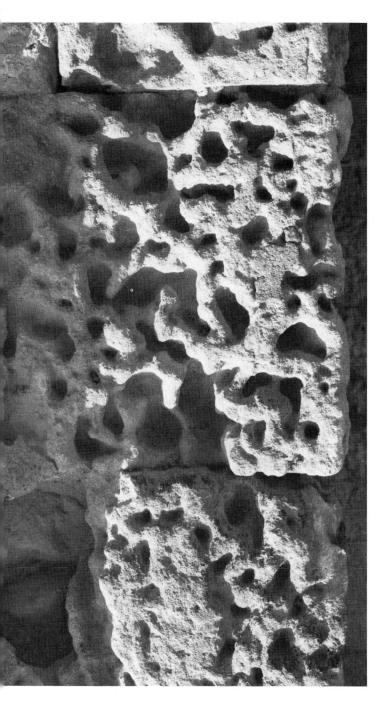
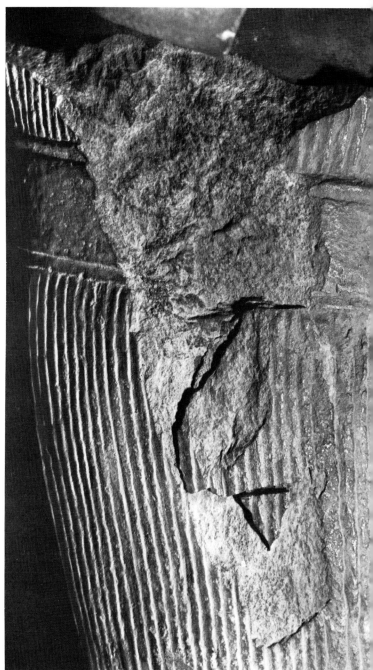

PATHOLOGY OF STONE

Depending on their composition, the degree of exposure, their situation in the building, and the nature of their surroundings (i.e. whether rural or industrial), stone statues deteriorate in different ways and as a result of highly complex processes. Works carved in limestone tend to suffer from alveolation (ill. 2) or honeycombing, the body of the stone breaking up and coming away in the form of sand or powder; they also suffer from exfoliation (peeling) whereby the outer skin of the statue, which is harder than the core, tends to detach itself in the form of a blister or crust. Once the skin is gone, the lower layers harden and peel off in turn until there is nothing left. Sandstones exfoliate in the same way (ill. 3). The Khmer statues are losing their skin in whole slabs several millimetres thick, and when you tap a place where the skin is still intact you can tell from the sound that it will not be long before the surface separates from the core of the stone. White marble becomes saccharoid, the crystals of which it is composed losing the power to imbricate with one another to form a hard mass; limbs of statues break off, and wind and rain erode the marble as if it were a sand-dune, leaving faces that look as if they have been ravaged by leprosy.

The present state of research allows us to sum up the phenomenon as follows: stone has a certain porosity; when exposed to the weather, or when it is in contact with damp ground, it absorbs and gives off water, which acts as a vehicle for various harmful agents. These may be physical, such as frost; chemical, such as the mineral salts formed by the constituents of the rock reacting with acid elements from the atmosphere; or biological, such as the bacteria brought to the surface by rising ground-water.

Statues standing on their own or against monuments make particularly good "evaporators", indeed they act almost like a still, giving off pure water whenever the sun shines, and retaining a little bit more of the salts brought by rain and rising damp. In all problems to do with conservation, water is enemy number one. The source of life, it is also a prime source of destruction. Physically it beats against the stone, wearing it away if it is at all fragile. It finds its way into porous stone and may freeze there; increasing in volume as it crystallizes, it shatters the adhesion holding the components of the stone together.

The chemical problems are infinitely more complex and varied. The recent acceleration of deterioration has drawn the attention of those responsible to atmospheric pollution, pointing an accusing finger at the sulphur dioxide content in the air of our cities. But many damaged sites are out in the country or in towns with very low pollution levels, and here we can only blame the salts in the soil finding their way up into the stone.

Whether the damage comes from above or below, chemical analysis of the crust or powdery surface of a piece of diseased stone shows a high content of soluble salts (i.e. those that can be carried by water): sulphates, chlorides, nitrates. These salts, present in all types of deterioration, are hygroscopic, and alternate humidification and desiccation, by changing their crystal sizes, set up tensions in the pores of the rock and cause it to split. On the other hand, spreading by osmosis in a piece of water-saturated stone, the salts then have a tendency to rise with the water towards the point of greatest evaporation and become concentrated beneath the harder surface layer, setting up tensions there that will eventually

cause the skin to separate from the core of the stone. If you think that in a piece of Alsatian sandstone, for example, which is composed of quartz and a non-calcareous, siliceous cement, exfoliation is due to the presence of calcium sulphate formed by the sulphur from atmospheric pollution and calcium from the lime jointing, wind-borne dust, or bird droppings, you will begin to appreciate the complexity and diversity of the causes of chemical attack.

The microbiological aspect of deterioration in limestones and sandstones would appear to be even more significant. Soil microbiologists tell us about biological cycles centring on nitrogen and sulphur in which bacteria play a key part. Certain micro-organisms are capable of utilizing the nitrogen molecule directly (azotobacter aerobes, *clostridium pastorianum,* anaerobes); these bacteria accordingly fix nitrogen in stone in the form of protein. Large numbers of other bacteria mineralize this nitrogen as well as that deriving from animal and vegetable tissue in the form of ammonia, which is oxydized into nitrite and then into nitrate by a third, highly-specialized class of bacteria (nitrosomonas and nitrobacter), thus setting things up for the process of chemical destruction described above.

Bacteria put sulphur through approximately the same cycle. Metalloid sulphur and reduced sulphur may be oxydized, forming sulphates. This reduced sulphur may derive either from the mineralizing action of certain bacteria on organic sulphur compounds or from the reduction of sulphates by other anaerobes bacteria ("desulphuricans"); this is what is happening – and it is very serious – to the temples and sculpture of Angkor, where most of the sulphur comes from bat droppings. The most dangerous bacteria are the ones that oxydize ammonia and the ones that oxydize sulphur dioxide (SO_2); they actually derive their energy from these oxydization processes, need no organic substances, and produce powerful acids – nitric or sulphuric – the corrosive action of which is of course intense.

Even this brief glimpse of the "diseases of stone" gives an idea of the complexity of the problem and the difficulty of finding a solution. What is being done in the countries concerned to preserve our masterpieces from destruction?

ORGANIZATION OF RESEARCH

The various laboratories that have been set up since the Second World War to combat the diseases of stone are all still at the research stage, which shows how enormous the problem is.

In France, for example, the basic problem and the co-ordination of research have since 1967 been the responsibility of the Historical Monuments Research Laboratory (the "Laboratoire de Recherche des Monuments Historiques" or L.R.M.H.), which supervises the work of restorers and keeps them informed about its research programme. It collects all the information available; records any fresh discoveries made in France or elsewhere; goes out and takes large numbers of samples at the request of architects. It also co-ordinates the study programmes of various specialist laboratories, such as the Oceanography Research Centre, which studies deterioration processes under simulated conditions; the Building and Public Works Experimental Research Centre, which studies the problem of repelling outside damp; the Petrography Research Centre, which carries out chemical analyses; Strasbourg University's Geological Institute, which

17

makes a special study of the local sandstones; and finally, the Atomic Energy Research Centre at Grenoble, which has high hopes of the polymerization of monomers by gamma radiation (we shall be looking at the results of this on wood in the next chapter).

All these laboratories come under the supervision of the Stone Commission ("Commission des Pierres"), which has set itself two aims:

– First, to establish a proper pathology of stone, using in-depth research procedures to isolate the diseases of stone, determine their cause, nature and mechanism, trace their development, and extract laws from the resultant findings.

– Second, as regards treatment, to find methods that suit the characteristics of each type of stone and the nature of each sort of attack. Research in this field, which involves systematic experimentation with treatment processes and products, should lead quickly to practical results.

METHOD OF RESEARCH

These research laboratories pursue two distinct yet perfectly complementary types of research. On the one hand they seek to reproduce the different kinds of deterioration on samples of sound stone by subjecting them to simulations. On the other hand they look at the facts *in situ* by taking and analysing core samples of diseased stone and studying the climatology and hygrometry of particular monuments. We shall now deal with several French methods of research and treatment.

In order to reproduce in samples of sound limestone the types of exfoliation and blistering encountered in statues and monuments the L.R.M.H. uses accelerated ageing equipment (ill. 4) that subjects

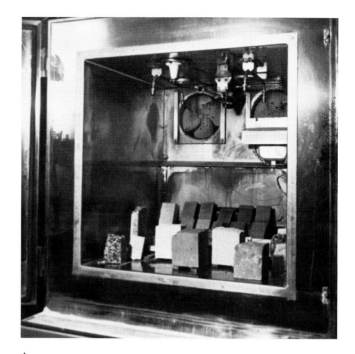

4
Accelerated-ageing enclosure, reproducing cycles of aridity and rain, heat and cold on samples of sound stone.

the stone to the worst possible climatic conditions with alternating rain and dry spells, frost and heat. On the other hand a balance system makes it possible to keep a series of samples that have been saturated with calcium sulphate at a perfectly constant, known level of humidity. Periods of sunlight alternate with periods of humidification, these cycles being governed by a programmer, which also fixes their length.

Using this method, it is possible to subject stone to the effects of rising damp of various chemical compositions or to the leaching action of artificial rain, also in various constant, known compositions. This accelerated ageing and simulation treatment is also

invaluable when it comes to testing different treatments.

Apart from these simulations, a lot of time is devoted to studying the facts in the field. The L.R.M.H. has a mobile laboratory that takes samples of diseased stone and analyses them by comparing them with sound samples of stone of the same origin, which will eventually make it possible to draw up a proper theory of the distribution and nature of the salts occurring in diseased stone.

Certain monuments have become virtual research laboratories in themselves, three examples in France being Aubeterre church, in a rural environment; La Rochelle's Saint-Sauveur, in a coastal environment; and Saint-Louis des Invalides, in an urban environment. Climate stations have been set up there to record air-pollution levels over the years. The rainfall they receive is measured with the aid of equipment that collects both streaming rain and impact rain, and the water collected is analysed. Other equipment records the distribution and duration of rainy periods, the duration of sunny periods, and the temperature and humidity of the walls at various depths, all these readings being taken on a number of different orientations.

The sum total of these observations and experiments, classified and compared with the physical, chemical and microbiological phenomena associated with the deterioration of stone, will make it possible to establish laws of correlation between exfoliation or alveolation and the different forms in which water is present: rain-wash, impact rain, rising damp from the ground, permanent damp or damp alternating with periods of evaporation, pure water or water containing salts taken from polluted air or from the ground and the monument's foundations. Once we understand completely the general phenomena affecting stonework and the phenomena peculiar to a building or a series of statues, we can go on to look at the question of treatment.

TREATMENT

Since we can have no influence on the climate of a particular region and very little on the circulation of ground-water, and since at the same time we are reluctant to confine to museums all the works of art that were created to live in the sun, what we have to try and do is to prevent water from penetrating the stone we wish to preserve or rising in it by capillary action.

An initial responsibility falls to the architect, because proper upkeep of the building supporting the statues is essential. He must keep a permanent look-out for the leaking gutter and the gargoyle that the pigeons block up six times a year. A few simple building operations will ensure that water does not stand at the bottom of the walls but drains away. And besides this constant vigilance the architect must take maximum advantage of the whole arsenal of products that the construction industry offers nowadays in the way of roofing felt, plastic sheeting and adhesive cements.

The remedy envisaged by the L.R.M.H. to prevent rising damp from eating away the statues at Moissac or splitting the carved pillars of Angkor Vat is both extremely simple and enormously ambitious.

At Angkor they have been practising this remedy for some time. A combination of cheap labour and a simple method of construction made it possible to perform what has wrongly been referred to as anastylosis (literally, telling the height of a column from

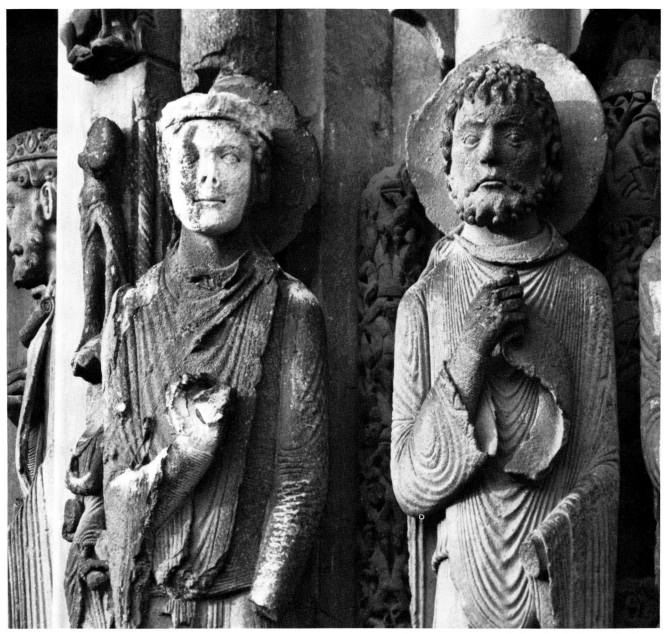

5/6
These pictures show a detail of the Royal Portal of Chartres Cathedral before and after replacement of one of the statues. It is clear which is the copy; nevertheless the rhythm and colouring of the portal have been preserved, and the original is now safe in a museum.

20

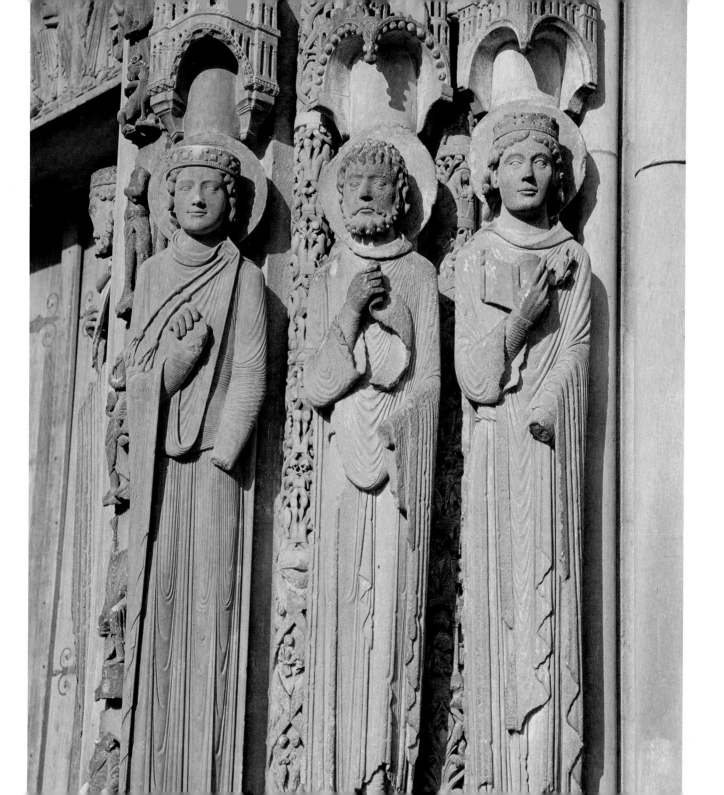

the diameter and taper of a single tambour, and so reconstituting a Greek temple on paper from a limited amount of evidence). In Cambodia, where the process was perfected by Bernard Philippe Groslier, entire monuments were dismantled – even up to small mountains, such as the Baphuon – each stone carefully numbered, a concrete slab or frame poured, and the whole structure re-erected on this damp-proof course, which then stopped the rising damp that had previously carried salts and thiobacilli from the ground up into the stonework. In Europe the presence of bonding materials in the masonry of our monuments completely rules out this approach. The L.R.M.H. is currently developing a machine that will saw through the damaged monument at its base, filling in behind the saw blade with some damp-proof material such as a silicone elastomer. One can imagine what it would cost to insulate all our monuments in this way!

Research laboratories are using their simulation equipment to study a series of water-repellents and stone consolidators. Research in this field needs to be very thorough indeed and the practical side of the operation embarked upon with the greatest circumspection; in fact there is considerable risk of doing more harm than good.

Water-repellents, e.g. silicone compounds or fluosilicates, when applied to the surface of statues or ornamentation exposed to rain, do not completely seal the pores of the stone and consequently do not prevent evaporation, but their capacity for making materials non-absorbent (by altering the forces of capillary tension) means that water striking the surface of the stone will roll off without penetrating it – as off the proverbial duck's back. So the stone repels water without in fact becoming water-proof; on a horizontal surface, for example – such as a cornice or the top of a statue – or in the hollows formed by exfoliation or alveolation in a piece of already diseased stone, water may very well sink in. On the other hand, water-repellents cannot prevent damp from rising by capillary action behind the treated layer, which can hardly exceed a few millimetres in thickness. In this case the presence of a water-repellent may be more drastic than its absence, causing considerable pressure to build up behind the treated surface, which then blisters and breaks away. One can appreciate why restorers and architects are so cautious about applying these remedies.

Although the best water-repellents are almost completely effective in repelling water, they do nothing to consolidate stone that is already decaying and friable, and another whole area of research is devoted to injecting stone with various consolidating agents that will have the effect of rebinding the deliquescent portions. In the case of statues that can be taken down and then put back or placed in a museum, the products – polyester, epoxy, or methacrylate resins – can be injected in a vacuum and polymerized by gamma radiation (by the method developed by the Atomic Energy Research Centre at Grenoble and described in Chapter Two). Impregnation treatment of this kind appears to give excellent results in ageing tests; the salts may even be imprisoned completely inside a perfectly consolidated mass. But the method is impracticable on very

7
Used conscientiously, this traditional method of finishing makes for a faithful copy without possibility of interpretation.

large pieces, and even more so on whole monuments. Here one has to rely on capillary absorption. No matter how porous a piece of stone, however, it will not absorb much resin before the latter polymerizes, and the stone will be consolidated only to a depth of about three millimetres. Measurements of the stripping resistance of this artificial crust show that beyond those three millimetres there is no cohesion with the core of the stone. This type of partial surface consolidation may stop the humidification-desiccation pendulum, but at the very serious risk of setting up tensions between the consolidated and unconsolidated material, and having the surface break away. Even after accelerated ageing tests, researchers are rightly inhibited as regards carrying out *in situ* consolidation treatment by the impossibility of knowing how such treatment will react over a period of a century or more.

The safest treatment is still simply to take down the major masterpieces of monumental sculpture and replace them with reproductions (ills. 5-7). This may be the policy that emerges from the systematic research that has been going on for a number of years. The sundial angel and three column statues at Chartres have already been replaced by excellent reproductions. The originals will not be thrown into the Seine, which is what Viollet-le-Duc did, but will go to enhance cathedral museums. The question is: Will we manage to avoid the weaknesses of the copyists who worked on Vézelay and on Notre-Dame, humbly remaining faithful to the Romanesque or Gothic spirit, and not imposing our own style despite ourselves? This is the subject of a lot of controversy, and the supporters of the removal solution are few and far between. So are the sculptors who could do the work, though at least one can say that they would not have the pretensions of their nineteenth-century predecessors. None of them would see themselves as improving on the work of the men who carved the Royal Portal at Chartres. Modern copyists are content to be just that, practising their trade in all fidelity and humility and inventing nothing themselves, thanks to their scrupulously mathematical approach. The big problem is how to train enough sculptors, because those at present available could be counted on the fingers of one hand. Art education nowadays is all creation-oriented, and it might not be a bad idea if we adopted the Japanese system of the State supporting completely a number of really good sculptor-copyists on condition that they train a team to succeed them.

The treatment and consolidation of a work that has been removed from its building and is destined for a museum are child's play in comparison with the conservation of sculpture *in situ*.

The decaying statue is soaked for several weeks in industrial water and afterwards in demineralized water. The soluble salts — calcium sulphates, chlorides, nitrates — are evacuated by osmosis, and eventually, after several changes of water, eliminated entirely. In most cases the surface of the stone will, after drying, recover sufficient hardness to keep in a museum atmosphere (ills. 8 and 9). Where consolidation is necessary, even superficial impregnation with resin (polyester, epoxy, or methacrylate) will not have the same disadvantages in a dry, stable climate. If the piece in question is not too large it can be consolidated right through by the method developed at the Atomic Energy Research Centre at Grenoble (see Chapter Two for a description of the principle involved).

If the piece is too large to be submerged and treated by osmosis, the soluble salts can still be eliminated by saturating the statue in water and covering it with a thick layer of cellulose paste. We have seen how the salts move towards the surface of greatest evaporation and become concentrated there, near the surface, without emerging from the stone. Applying a blotter compress of cellulose paste is equivalent to shifting the evaporating surface outside the statue; as this dries out the salts will pass out of the actual body of the work and become concentrated in the compress, which is subsequently removed.

The key to the current struggle against the ailments that are attacking our sculptural heritage must lie in action combined with lucidity of approach. We are now aware of the drama threatening almost all of our monumental stonework; we must devote ourselves without delay to the therapeutic measures that, after as brief an experimental phase as possible, will, one hopes, be universally adopted in the campaign to preserve our statues and monuments from certain destruction.

Cleaning stone

It is an unfortunate fact that cleaning processes tend to be violent in proportion to the size of the piece to be cleaned. The wall of a building will be sand-

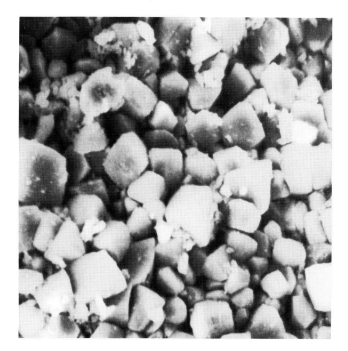

8/9
Sections through a limestone from Vassens (France), seen through an electronic scanning microscope (magnified 1400 times).
8 Before treatment.
9 Afterwards, with the grains reassembled.

blasted, while a Burgundian mourner will be cleaned with a cotton-covered stick – as if the façade of Saint-Denis were somehow less precious! Great masterpieces must be cleaned with the very greatest care, whatever their size. It is a question of money, time and patience.

Sand-blasting – squirting a mixture of sand and water through a hose under pressure – abrades stone in a way that is not only irreparable but also difficult to control; it is out of the question as far as sculpture is concerned.

The gentler method of cleaning with a water spray is performed in three phases: the piece is washed down in order to remove dust and soften the dirt, scrubbed to remove the dirt, and finally rinsed. The degree of cleanness achieved depends on the porosity and grain of the stone, and above all on how well the scrubbing is done.

Cleaning with chemicals, particularly ammonium fluoride mixed with a thick, pasty excipient, gives excellent results. It has been widely used, without doing any damage, on the bas-reliefs of the Bayon temple at Angkor Thom, which had become illegible beneath a combination of grime and lichens. It leaves the surface hardness unaffected, and if the stone being treated is still solid – i.e. not powdery – there is no fear of the skin coming away. Ammonium fluoride can be used on marble (ill. 12), sandstone or limestone. A limited area of the surface is moistened and the paste brushed on and left for about twenty minutes. The restorer then brushes the area carefully with a wire brush (brass) under running water, taking care to rinse the statue very thoroughly afterwards. Potassium and sodium-based products with an alkaline reaction are not to be used on any account.

The choice of method depends on the composition and amount of the dirt covering the statue as well as on the nature of the stone underneath – whether polychromed, dense and impermeable, or porous and friable. The same golden rule of restoration goes for sculpture just as much as for painting, namely that one makes a series of cleaning trials, starting with the most gentle and working up to more violent ones, but above all remaining flexible in one's approach. Sometimes dusting is enough, or rubbing with the crumb of a loaf of bread; sometimes a good wash with clean water will work wonders without doing any harm to a piece of polychrome sculpture. A marble bust that has been sitting in a drawing-room collecting dirt and dust will simply be washed, as one does the washing-up, in warm water and soap (ill. 13). A garden marble encrusted with lichens and stains will need ammonium-fluoride treatment before it recovers something of its original whiteness. A limestone statue covered with a hard coating of black grime will need to soak for several weeks before the grime softens enough to be brushed off. Finally, there will be times when the restorer has the good sense to do nothing at all, times when such dirt as is present can still be called patina and regarded as enhancing the stone. One thinks of that fine pink dust and of certain minute lichens that make sandstones or marbles vibrate by bringing out the tiniest chisel marks.

10/11
There would be nothing left of the Moissac sculptures if they had been deteriorating since the twelfth century at the rate they are deteriorating today. This disturbing acceleration of the process has stimulated active research into the diseases of stone.

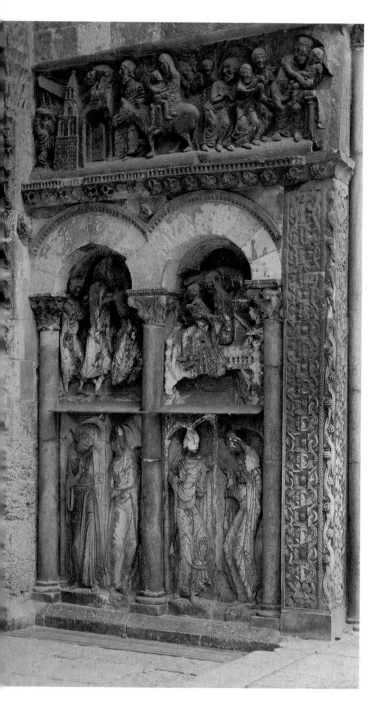

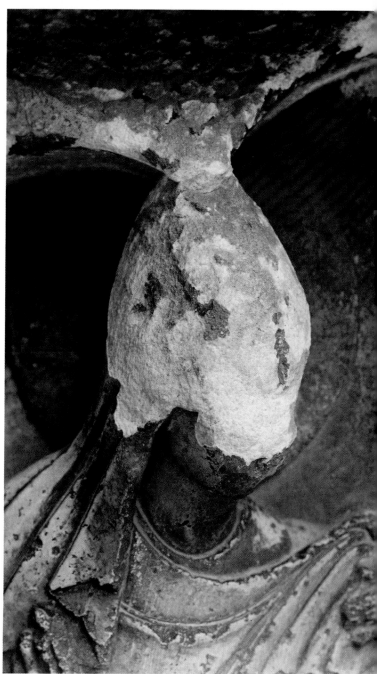

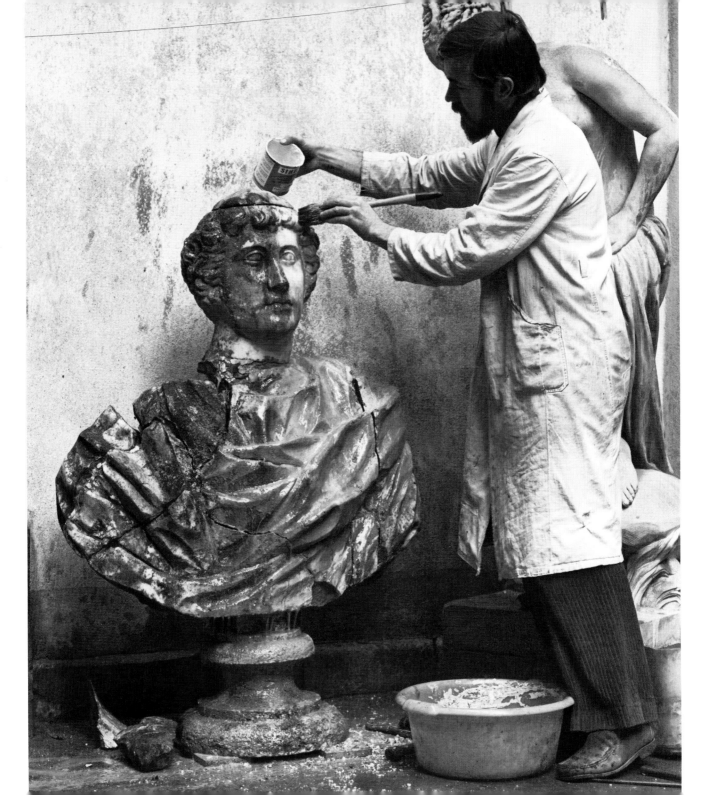

Stripping polychrome statues

Medieval polychrome stone statues have often suffered the same fate as so many wood-carvings in that their original paintwork has been covered with successive coats of overpaint. They are stripped in the same way as polychrome wood-carvings, with the same preference being given to the dry-stripping method carried out with infinite patience. One thing the restorer must bear in mind is that many pieces were painted on a yellow ochre ground, which he must be careful not to mistake for the original paint layer.

It is also vital to be able to tell when an originally unpainted piece of sculpture has been daubed at some later stage. Here the restorer can get rid of the paint with fairly liberal applications of paint stripper (again avoiding potassium), provided that he rinses the piece very thoroughly afterwards.

Repairs

Apart from conserving and cleaning stone statuary the restorer is often called upon to repair it. This may mean anything from reassembling various scattered limbs to renewing a nose or a hand, either camouflaging the scars or leaving them visible, depending on the spirit in which the restoration is carried out.

In this section I propose to describe the process,

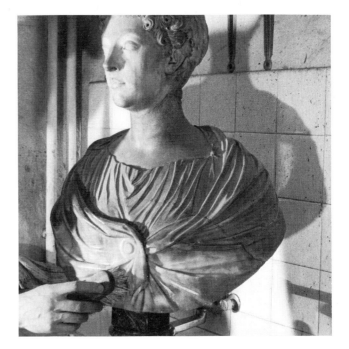

13
Cleaning a polished marble with soap and water and a dash of alkali.

right up to the final retouching, by which objects are restored that it is intended to place indoors. Open-air statuary is repaired in the same way, but without the camouflaging, which is impossible on stone that is exposed to damp and frost; it is also frequently unnecessary in the case of monumental sculpture, and it is in any case contrary to the museographical spirit in which historical monuments are preserved. Outdoor restoration concentrates above all on making sure that the adhesive and dowel-pins used will stand up to frost and water. Here again the L.R.M.H. spends a lot of time testing various adhesives, cements and dowel-pins for their suitability in conjunction with different types of stone.

12
Cleaning a stained and lichen-covered marble with ammonium fluoride.

29

FIXING BROKEN PIECES TOGETHER

When it comes to mending stone statuary, glue alone is hardly ever strong enough. It is a question of ratio between the mass of the two sundered elements and the area to which adhesive can be applied. An epoxy-resin adhesive (Araldite) will glue a nose on a bust, it may even glue the tip back on a finger, but it is quite impossible to reattach an arm, let alone a body that has become separated from its base at the ankles, without using metal dowel-pins to provide a solid bond between the two fragments.

This of course involves drilling holes in the fractured surfaces (ill. 14). In the old days the restorer had neither our modern drills nor tungsten-carbide bits. He worked with a brace or bow, and his bits were hand-forged. It might have taken him several days to make a hole in a piece of sandstone, so quickly did the stone blunt his bit. We even know of cases where, rather than bore two holes in the core of a broken leg, the restorer settled for riveting the member back together through the skin of the statue. One can imagine how solid and aesthetically-satisfying that kind of restoration is!

Today's restorer can choose from a whole range of portable electric drills with mechanical or pneumatic percussion action, taking bits made of tungsten carbide that enable him to drill large, deep holes. Marble masons and lapidaries are nowadays even able to bore into the hardest materials (granite, quartz, etc.) with enormous precision, using soft-iron tubes turning in a pile of moistened carborundum dust or trepans with a copper crown containing powdered diamond.

In order to fix two fragments of stone together it is necessary to drill a hole in the centre of each fractured surface in such a way that the two holes correspond perfectly in axis and direction and can receive the largest possible dowel-pin, enabling the fragments to engage completely with each other. The operation becomes extremely tricky when the fracture is very much at an angle to the direction the holes have to be bored in. Other complications arise when the repair calls for several pairs of holes, e.g. to fix two spread legs on a single base, when the fracture is no longer a clean one and the elements to be reassembled no longer engage properly, and when one is dealing with a combination of large masses and small fractured areas, as in a statue that has broken off at the ankles, where the restorer must bore deep holes up into the thicker part of the calf or thigh.

There is a simple method of boring two matching holes. You start by making one hole as near as possible to the centre of one of the fractured surfaces. Taking a pencil, you then draw two lines more or less at right angles to each other, both lines passing through the centre of the hole. Extend these two lines a little way down the skin of the statue, place the two fragments together, and transfer the pencil marks to the other fragment. When the four marks on the second fragment are joined with two straight lines, the point where those two lines cross will give you the centre for the matching hole (ills. 15–18). Using tungsten bits and a non-percussion drill (the percussive action could be dangerous), it is best to bore a small hole first and make it bigger by using progressively larger bits.

14
Drilling a classical marble with a sensitive drill and a trepan.

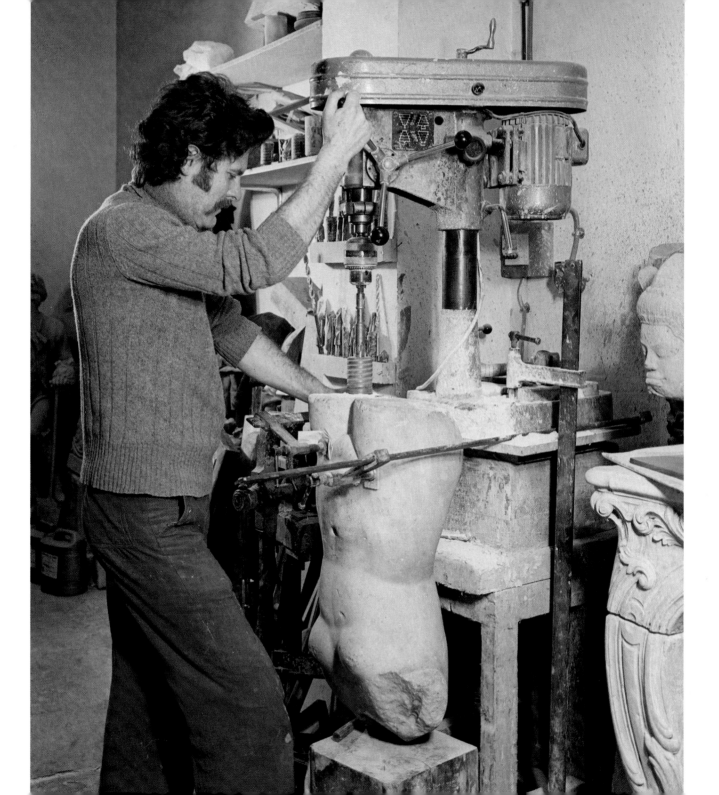

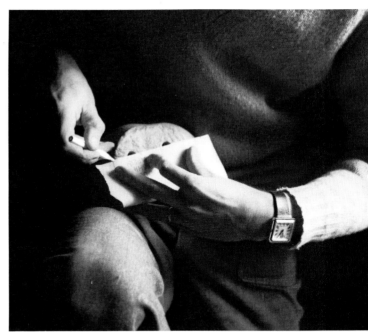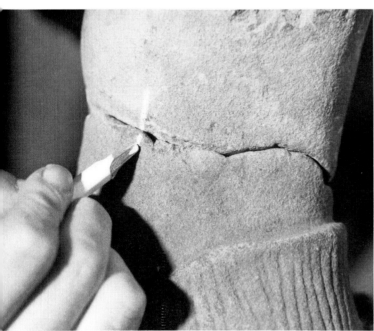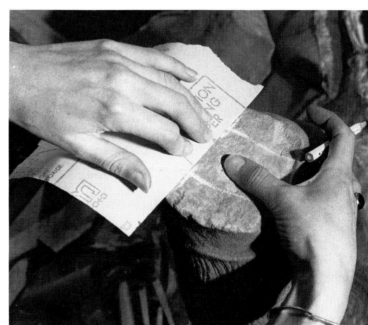

The diameter and depth of the holes are a matter for the restorer's common sense. If the holes are so large that there is very little stone left around them the statue will be weakened, no matter how big a dowel-pin is inserted. In certain cases this is all right, namely when the hole extends deep into a thicker, more solid part of the statue (e.g. from a break at the ankles), but as a rule the diameter of the hole and its dowel-pin will be governed by an optimum ratio between the strength of the stone and that of the pin. (An example would be, for an arm broken off the body of a life-sized statue, twenty to twenty-five millimetre-diameter holes taking fifteen to twenty millimetre-diameter dowels.)

The pin is cut from a round brass or occasionally stainless-steel rod. Iron is to be avoided at all costs: it rusts, swells up, and bursts the stone, as many statues formerly repaired with iron pins testify. The surface of the pin is roughed up with a file, metal saw or emery wheel to make it grip better. It is then placed in one of the holes and the two fragments are brought together (with a heavy statue this may call for a hoist or travelling crane). The restorer checks that the pin is not too long and in no way prevents the two fragments from knitting together. If it does, his best course is to adjust the diameter of the holes rather than that of the dowel-pin.

The two fragments are now ready to be joined (ill. 19). Here the restorer must work fast and accurately, because modern adhesives harden very quickly. Restorers nowadays no longer use cement, which creates a thickness within the fracture and provides insufficient adhesion. They prefer one of the polyesters manufactured for the marble industry. The L.R.M.H. has tested several brands, of which Sintolit and Akemy are both satisfactory.

The holes are carefully freed from dust with the aid of compressed air or a brush. The requisite amount of polyester is mixed with its hardening agent (with experience one can estimate the setting time on the basis of the quantity of hardener used and the ambient temperature) and the holes filled with a spatula (ill. 20). The dowel-pin is then itself coated with polyester and placed in one of the holes, and the two fragments are brought together and squeezed hard to make the polyester spread through the fracture as much as possible. Any excess polyester that runs out on the skin of the statue is wiped off with a rag dipped in alcohol before it sets.

There is very little to it when the fragments are small enough to be handled; the operation becomes vastly more complicated when it is a question of putting a statue that weighs a ton back on its feet (ill. 21). Large holes have to be filled, and the statue has to be hoisted into place very quickly before the polyester sets; meanwhile this will have plenty of time to drip out of the holes while the statue is in the air (in fact the restorer will choose a thixotropic polyester and may even stop up the holes with sticking plaster during this phase of the operation). In the not more than five or ten minutes at his disposal before the polyester sets, he will also have to make sure that the two fragments engage properly, check the statue for position along both axes, and wipe off any excess adhesive. This is precisely the kind of situation that calls for an extra effort of the imagination on the part of the restorer. Possibly he can invent a

15–18
How to drill matching holes in two fragments that have come apart.

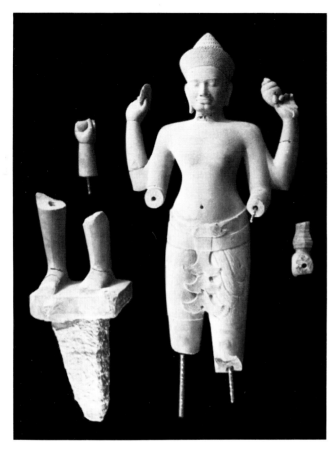

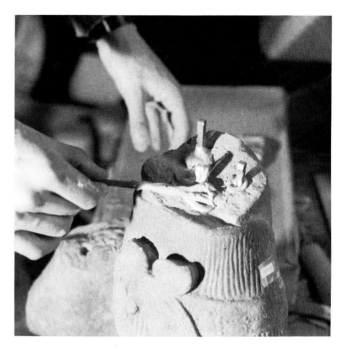

20
The refixing process.

19
◀ A statue ready for refixing. Note the nicks in the bronze dowel-pins to give them a better grip.

polyester injector, for example, or devise a particularly quick and accurate method of bringing large fragments of statuary together.

SOME SPECIAL CASES

Poor fractures: If the fracture is old and worn, with possibly even some material missing so that the two fragments do not engage normally, an intermediate stage is called for. The trick here is to fix the dowel-pin in the lower fragment, hoist the other fragment into position "dry", securing it there by means a system of strings and stays, and fill in any gaps with

polyester, just as if the fragments had in fact been joined. A jerk on the hoist will fracture the fill, but now the fracture will be a clean one.

Oblique fractures: It is difficult to bore a hole in the axis of a limb when the plane of fracture is very much at an angle to that axis; the bit keeps skidding away down the slope. The best way is to make a nick with hammer and chisel and then start with a small-gauge bit measuring five millimetres. Using a steadily larger bit, the restorer will always begin drilling at right angles to the fractured surface and

gradually reduce the angle until he is going in the right direction.

Large masses with a small area of fracture: The sculptor thought he could dispense with the column, tree-stump, or clump of reeds that were so often used to support a delicate *Venus,* and his figure has broken off at the ankles. Large-diameter dowel-pins are required here, possibly of stainless steel, but there is a danger of the figure breaking again at the end of the pin. The restorer must drill holes right up into the thicker part of the calf or thigh, and so reinforce the whole length of the leg.

Crumbly stone: Extremely friable types of stone such as the Gandhāra stuccos (if one may be allowed to classify this material with stone; restorers do) or certain very soft limestones are too fragile and porous to be repaired as they are. Before fixing his fragments together the restorer will take the precaution of filling the holes with shellac varnish or something similar, only proceeding further when this is dry.

Clean fractures: If the fracture is recent and extremely clean, and if the piece of sculpture is delicate enough to warrant being glued as one would glue a piece of porcelain, the restorer can use a combination of materials: polyester to fix the dowel-pin, but without overflowing the holes, and a film of epoxy-resin adhesive to glue the fractured surfaces (ill. 22).

21
The refixing process is more complicated on a large statue that has broken into a number of fragments.

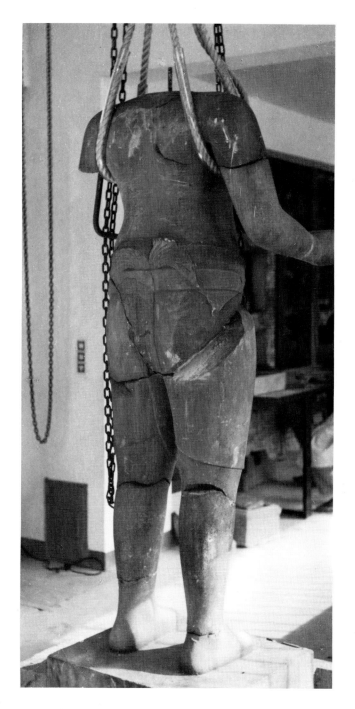

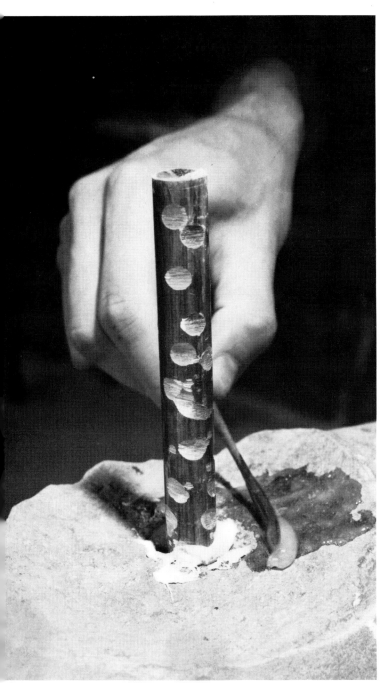

FILLINGS

The refixing method is the same for all materials, but the way a restorer fills the crack that is left after refixing or the various other holes and blemishes that he may want to plug will vary according to the type of stone concerned. It will further pave the way for the final process of retouching by matching the stone for hardness and colour (or transparency), and making it possible to imitate the skin of the statue perfectly, whether this is shiny, rough, granular or fissured.

Hard fillings: On Khmer, Indian or Javanese sandstone, Gandhāra schist, Egyptian granite, and all other types of hard, mat, opaque stone, the filling of repairs, cracks and holes is done with the same material as we used for fixing broken elements together (ill. 23 and 24). These marble masons' polyesters are sold either in the natural state or mixed with a charge that tints them or makes them thixotropic. The restorer corrects the tint to get as close as possible to the colour of the piece of sculpture he is working on by using powdered pigments. A Gandhāra schist, for example, with its slaty tones, will be filled with a plain polyester tinted with black and plumbago. The restorer mixes a small quantity

22
◀ The dowel-pin is bedded in polyester. A film of Araldite is spread over the fractured surface. This will give a very neat repair.

23
Renewing the cheek on a twelfth-century Khmer head. As it was, showing the desquamating sandstone.

24
Polyester is prepared and applied where material is missing.

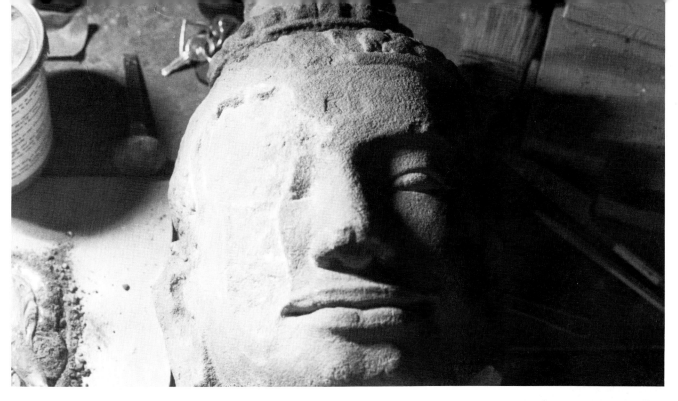

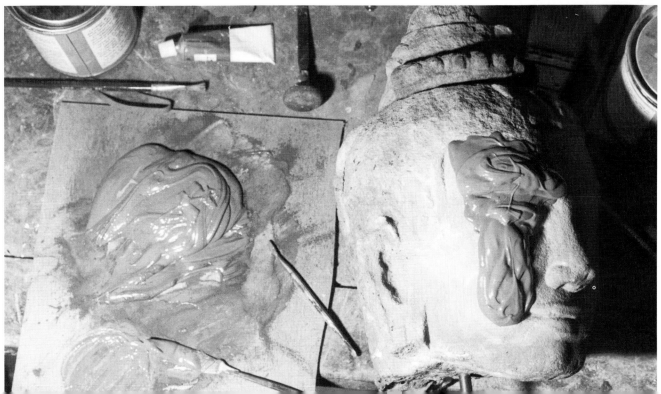

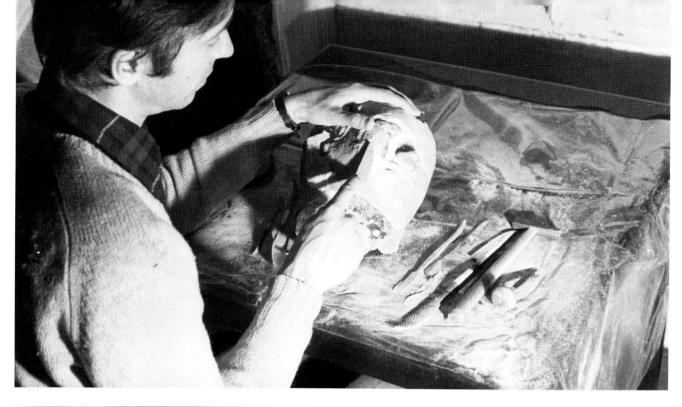

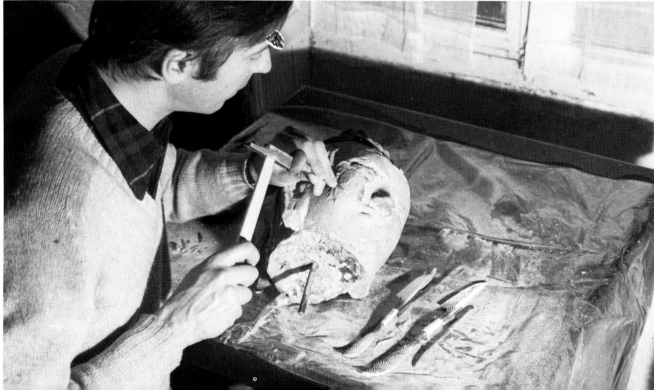

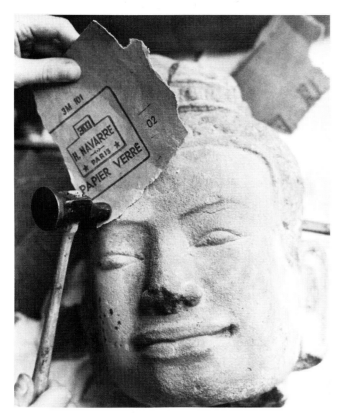

27
The polyester is made to imitate the rough texture of sandstone by hammering very coarse abrasive paper onto its surface.

28
Macrophotograph of a filling before retouching. The material is an almost perfect textural match.

of this prepared polyester with its hardening agent, forces it – in several batches, if necessary – into the crack or hole to be filled up to a level slightly above that of the surrounding skin, which he will be careful not to overlap too much.

25
The hardened polyester is worked with a riffler.

26
The new cheek is finished off with a chisel.

Now begins the longest and trickiest part of the operation. This consists in removing the excess polyester and reducing the filling to the level of the original skin. Even rubbing down a simple crack filling requires care, but the restorer will need to combine the qualities of sculptor and archaeologist if, as is sometimes necessary, he is to reconstitute a missing cheek (ills. 21–3) or nose in the style of the Eighteenth Dynasty, Angkor Vat, or the Hellenistic second century. Starting fairly boldly with a rasp or large marble riffler (ill. 25), he will finish the job

with a small riffler, graver or gouge (ill. 26). Polyester can always be added in paste form to polyester that has already hardened; in fact, this is the only way to fill an air bubble, correct a slip, or make up for a mistaken initial estimate. The process thus offers great flexibility and allows of second thoughts at any stage. All the restorer need worry about is not to let his tools touch the skin of the statue.

Once the split has been filled and smoothed off, or the nose or cheek reconstituted in the right style, we move on to a dramatic operation that consists in imitating the original material. Here the restorer's skill and imagination reign supreme. Restorers have been known to collect the powdered sandstone extracted by drilling and throw it onto a film of epoxy-resin adhesive; others have mixed it directly with polyester fill. Anything is acceptable as long as it does not affect the authentic portion. It is these little discoveries, sparked off by ever-new problems, that make restoring the fascinating job it is.

My advice, however, would be not to try too hard to imitate the grain of a piece of stone by using the same material but to sculpture it in the neutral material polyester. The different grains of sandstone and other western stones can be reproduced perfectly by hammering onto the surface of the filling the right gauge of abrasive paper (ills. 27 and 28). The restorer must steep himself in the texture of the original, analysing it minutely and, for example, noting the logic of certain fissures in the stone, which he can then extend into the filled area with a graving tool. This kind of intimate knowledge of materials and surface textures enables the restorer to recreate by hand the flaky surface of a Gandhāra schist or the irregularities of Egyptian granite.

The danger, particularly with a sandstone that is at all friable, is of the polyester separating from the stone when hammered; this will produce a tiny rift around the edge of the filling, which may show through any subsequent retouching. The restorer must keep a sharp look-out for this and, if necessary, fill the rift, before retouching, with a softer paste made of pigments and rubber varnish.

Gloss fillings: On a bust of coloured marble with a shiny finish it may not be absolutely necessary to fill; a hair-line crack may not matter at all in a material with such varied tones. On the other hand one may want to stop up a large hole that, for example, throws an awkward shadow. This can be done either by fitting a piece of the same type of marble or with a tinted marble masons' polyester, which can be brought up to a perfect gloss with the aid of abrasive paper and polishing paste.

Fillings in soft stone: The filling material used must always be adapted to the hardness of the stone. When he is dealing with limestone or stucco the restorer will first size the crack or hole with poly-vinyl acetate adhesive and then fill it with lightly tinted plaster or with one of those ready-made cellulose grouts, which can be made harder by mixing them with a bit more polyvinyl acetate adhesive. Once dry, this kind of filling can be made to imitate a vast range of materials, e.g. by working it with a

29
A polyester filling on a highly translucent marble. Around the neck polyester has been applied in excess. After polymerization it will be worked with a grinding-wheel. The polyester used must have the same transparency as the marble.

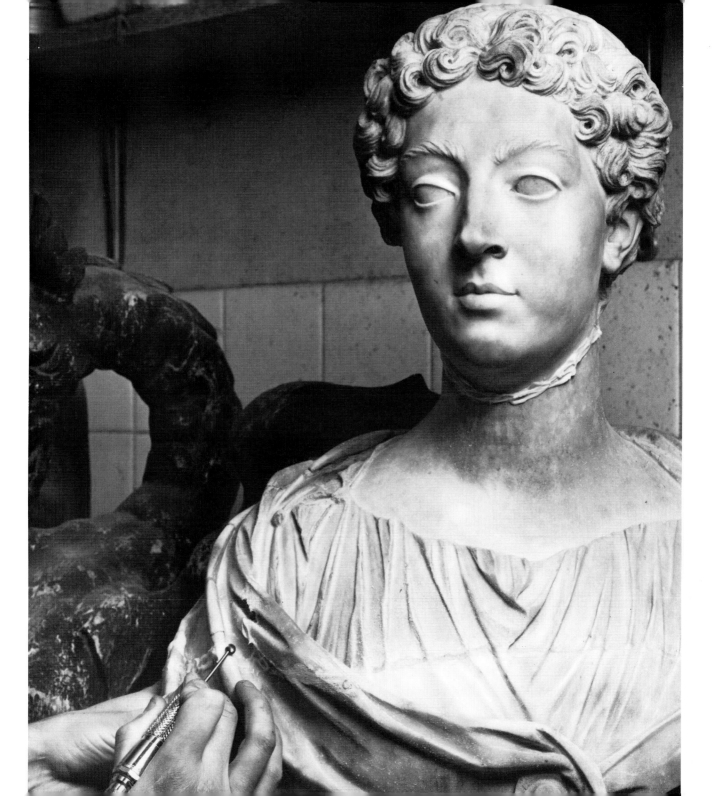

riffler or coarse sandpaper, or by mixing powdered stone with a further coat of adhesive. In fact, the restorer has every chance of recapturing exactly the grain and colour of the stone.

Transparent fillings: It will be readily appreciated how difficult it is to conceal a repair in a transparent material, such as glass, or even in one that is merely translucent, such as white marble (ill. 29) or alabaster. Light penetrates such materials to a depth of several millimetres; failing to penetrate the filled portion, it will inevitably make it show up. Of course one can always repaint entirely a white marble bust or an alabaster vase. This will effectively conceal any repairs, and, indeed, the restorer might be sorely tempted to adopt this solution, if he had not reminded himself from the start that it is at the filling stage that a repair qualifies as either elegant or a failure.

So he will attempt a transparent filling to match the texture of the marble, as has been done to repair Michelangelo's savagely mutilated *Pietà*. Many such attempts have been made, and it must be admitted that a lot of difficult translucent fillings have been rendered superfluous by essential but inelegant retouching. Just occasionally one strikes lucky with a marble that can be filled without retouching or with only slight water-colour correction. Some restorers have worked wonders by taking a white-tinted polyester and adding large grains of crushed marble; rubbed down and polished, this type of fill looks exactly like a Parian or Pentelican marble. On a fine marble such as Carrara, carefully tinted polyester may suffice.

The method is doomed to failure, however, when the fracture is old, soiled and jagged, or when the filling is not the same depth throughout. Often it will be in the restorer's interest to "own up", as it were, and occasionally he will even go so far as to chase a careful line round the edge of his filling with a graver. In fact, this is an extremely elegant solution, almost imitating an antique restoration.

SHOULD ONE RECONSTITUTE?

The problem occurs above all on a relatively subjective moral and aesthetic plane. To act or not to act — that is the choice, a very serious choice, with which the restorer is constantly being confronted.

There are of course purely (or basely) commercial considerations at stake that sometimes seem to have more to do with the process of putting a perforation back on a postage stamp than with any idea of fidelity to the work of art and the truth it represents. Fortunately, the scarcity of intact pieces and the appearance on the market of large numbers of mutilated classical statues have given collectors a taste for the mysterious quality of the fragment, a development that has very much reduced the number of improper commercial restorations.

Outside the antique business, each job of restoration is a case apart, and it is very difficult to extract definite, logical laws.

If the overriding principle nowadays, as far as historical monuments and museums are concerned, is never to complete any piece of sculpture, never to reconstitute a single head on a cathedral portal or nose on a classical bust, people nevertheless recognize how ghastly a mutilated park statue looks brandishing a handless stump. But why should one reconstitute the missing portion in the one case and not in the other? It is always an intellectual reasoning process that makes the restorer decide whether

he should renew a nose, or a breast, or merely limit his restoration work to cleaning and refixing the original fragments.

Perhaps after all we can make certain distinctions: on the one hand, between sculpture that is decorative, or regarded as such, and sculpture that is looked upon as great art; and on the other hand, between pieces that are remote from us in time and space and pieces that are intimately related to our own lives, e.g. an eighteenth-century bust. One would not have too many scruples about reconstituting a hand on a garden statue; what is a slight error of interpretation going to matter on a work that is there primarily as a silhouette? But one would think more than twice about completing a Donatello or a Michelangelo.

One will never reconstitute the leg of a classical statue or the head of a twelfth-century column figure. The modern mind accepts them as fragmentary; they wear their amputation well. In any case we do not know what they looked like new. Their surface is eroded, patinated, possibly diseased, and any incompleteness is obscured by this general impression of wear (ill. 30).

On the other hand an eighteenth-century French white marble bust belongs to our world, may even form a part of the décor in which we live, and apart from the fact that it disfigures the portrait, the absence of the nose, say, is intolerable to us (ills. 31 and 32). Our imagination, which would complete the piece mentally if it dated from the classical period, is put off by the perfect surface of the marble, and we see only a gaping hole.

There are many other reasons for acting or not. For example, is there a good model available? Western restorers have often made casts or replicas. Does the

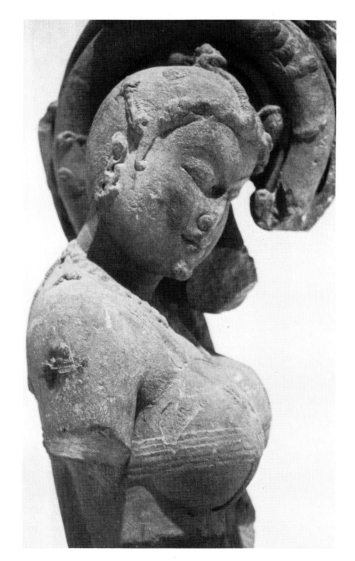

30
The scars on this face rob it of none of its charm. Restoration would be superfluous.

31/32
On this bust of Louis XVI in white Versailles marble the disfigurement is intolerable. It will be repaired on the basis of existing documents. White marble is one of the most difficult materials to retouch invisibly.

43

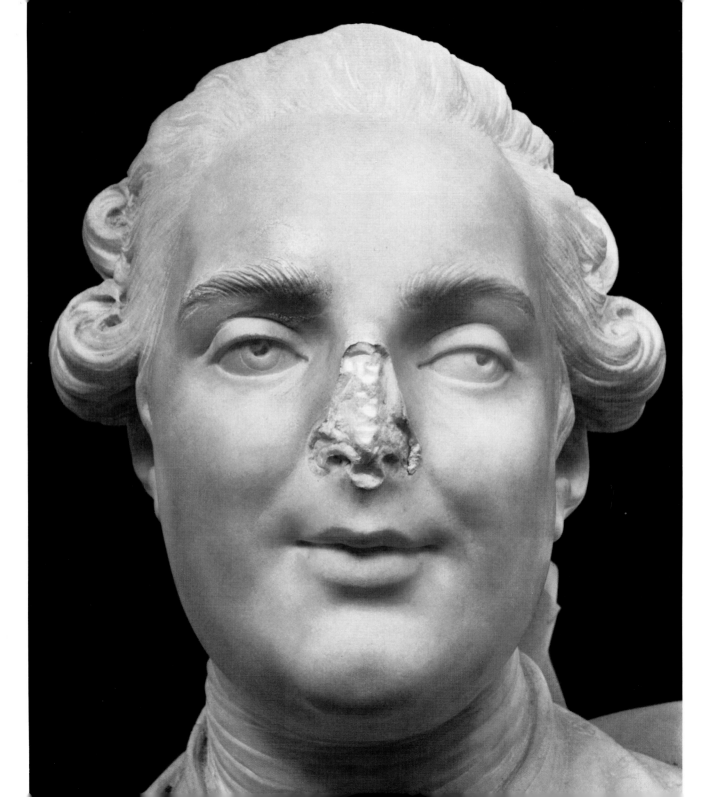

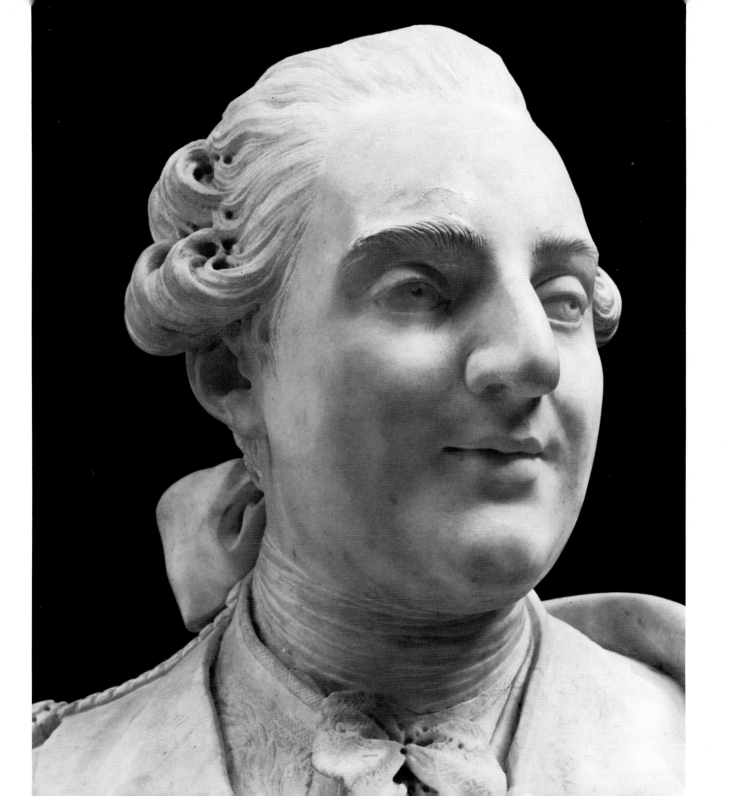

accident change the expression of a face? With a head, a tiny chip out of an eyelid may be taken for a pupil and give the subject an annoying squint, whereas a serious scar or deep erosion may not obscure the masterpiece. An awkwardly broken nose may throw a sharp, ill-placed shadow that can alter the very spirit and style of a work. A broken fold of clothing on a Gothic *Virgin* sometimes creates a shadow that may appear illogical and disturbing in the general balance of light and shade. Offered a statue with both its feet but only one leg, the restorer must choose between making a new leg (and leaving its newness just apparent) and a ghastly iron or cement prosthesis (ills. 33–5).

Some restorers, gathering in front of a work of art and asking themselves how far they ought to go with it, will draw up a number of hypotheses, some of which will be the product of logical thought and others of their instinct and taste – the latter being a factor that has evolved considerably, as we saw in our Introduction.

So the restorer may, under certain circumstances, reconstitute – but always on one condition, and that is that his work should be what restoration theorists refer to as reversible, in other words that it can be undone.

There was a marvellous restorer working in Paris about twenty years ago who was responsible for major advances in the field of classical bronzes and sculpture. As a devoted disciple of Benvenuto Cellini, however, he always tended to make a little swelling at the end of the nose! It was just right for a character portrait but rather less successful on an Amarnian head. What will future restorers think of our reconstitutions? It is surely no more than the most elementary wisdom to leave them a chance to

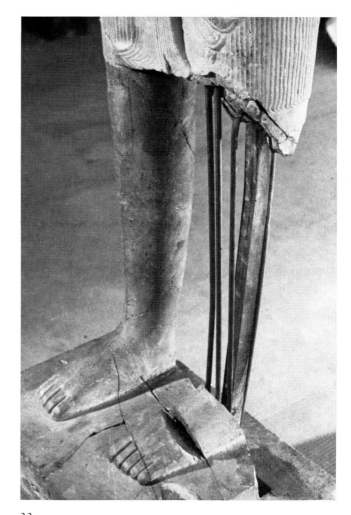

33
What is called for in this case is a just visible repair, involving a new, plastic leg.

34
First, a metal armature is prepared. The plastic is worked with a rasp. ▶

46

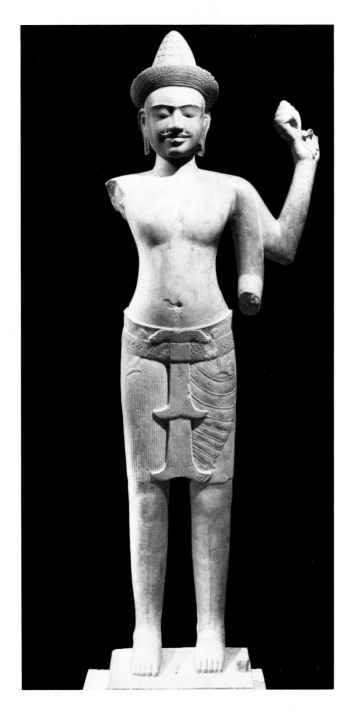

start again, or even simply to do away with what we have done. This is why one former method of restoration, for example, must be completely condemned. When renewing the nose on a classical bust, restorers used to take a piece of white marble, polish the fracture carefully to make the new bit fit better, fix it on with two iron pins, and then carve the new nose out of it. Apart from the fact that the dead straight line between the reconstituted and authentic portions will always be visible, this type of restoration is very awkward to suppress. How many classical portrait busts and even torsos have lost a nose or a breast as a result of a rusty iron pin having burst, leaving only a carefully flattened surface pierced with blackened holes against which the imagination is inevitably brought up with a jolt.

A small reconstitution on a large statue is best done in plaster or plastic, using if possible the material's own adhesion. A tinted polyester, subsequently touched-up, will often make a better restoration job than a piece of stone, which may not always quite match; and if the reconstituted portion ages badly or turns out to have been a manifest error of style, a tap with a hammer or a good solvent will restore the statue to its authentic state.

But a hand broken off at the wrist cannot, particularly on an outdoor statue, be reconstituted in plaster or plastic; it will have to be done in a block of the same stone. Flattening off a fracture at the

35
The finished restoration.

36
Spraying tiny drops of paint from a cropped brush to imitate the original sandstone.　▶

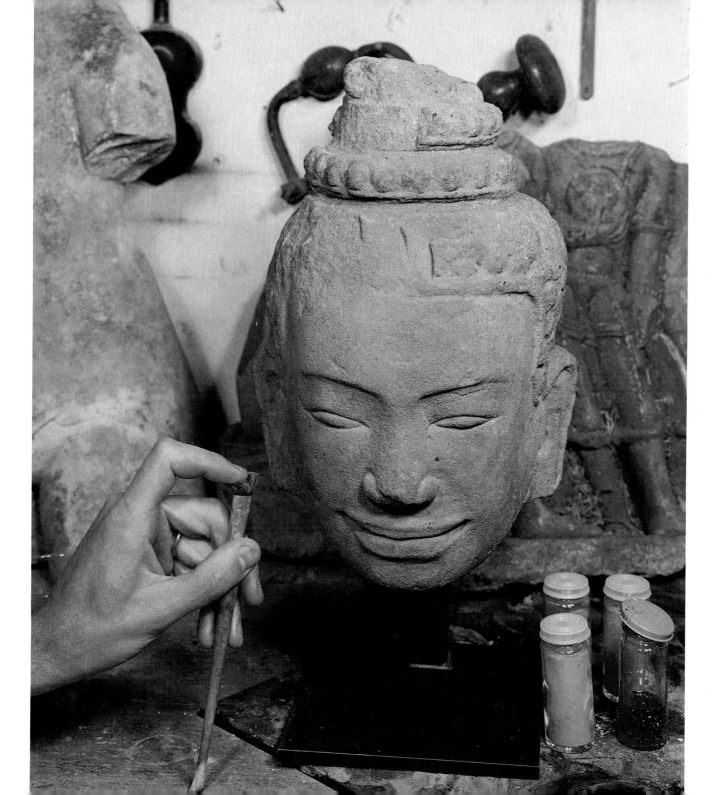

wrist, however, does not matter so much as flattening off the root of a nose. The restorer starts by making a clay model. He then carves this out of a block of stone (stopping just short of finishing it), fixes it onto the amputated arm, and completes the remaining details *in situ,* camouflaging the join and using his tools or sandpaper to recreate the grain of the stone or marble concerned.

In all these problems to do with reconstituting missing elements, the most important thing is to remain faithful to the work, to restore its balance and spirit. Recent advances in knowledge in the field of art history have been such that one hopes we can avoid the mistakes of centuries gone by.

RETOUCHING

Having refixed any fragments that have broken off and filled any offending cracks or holes, we come to the final stage of the restoration process, namely retouching.

When a word forms part of one's everyday professional vocabulary, one forgets what mysteries it may hold for the layman. In fact, this one could form the subject of a separate chapter, even of a separate book, a Leonardo-style treatise on mediums, coloured pigments and glazes. Retouching is covered at greater length in another volume of this series devoted to the restoration of ceramics, a field in which it assumes tremendous variety.

The point of retouching is either to camouflage a filling or reconstitution or, without hiding them completely, to restore the overall harmony of the work by finding a solution that is both skilful and honest and that will be visible from close to but invisible at a distance; the eye will capture the essence of the piece without distraction.

Retouching is the be-all and end-all of a certain type of restoration: how can I imitate in paint a Limoges enamel or a Sèvres porcelain – or, in this case, an Egyptian limestone, a Khmer sandstone, both made up of millions of tiny dots of colour one beside another, or a faintly translucent white marble?

Retouching is the end of what the restorer has to say, after which he surrenders the work, knowing he has done all he can. At the cleaning, repairing and filling stages one can still live in hope, but the final stroke of the retouching process constitutes a climax, and it is in the decision represented by that climax that the restorer exhibits his good taste.

A simple way of hiding a large filling in a piece of sculpture is, as we have seen, to repaint the piece all over. This is diametrically opposed to the concept of elegant retouching, which must confine itself to an area hardly exceeding the surface of the filling. Aside from museographical retouching, which keeps to the filled area on principle, a piece of invisible retouching will be judged as much by its modesty and discretion as by the degree of its resemblance to the authentic material.

We have seen already that the groundwork for the retouching process is carefully laid at the filling stage – so much so that occasionally the filling material is exactly right and retouching superfluous. This is seldom the case, but the fact remains that a piece of retouching will never be perfectly invisible unless the material supporting it is perfect to start with. One is often surprised at how easy this camouflaging process is and at how little paint needs to be added, if the support already has the right grain and is pretty close to the colouring of the original stone.

The restorer hardly ever uses ready-made paints as

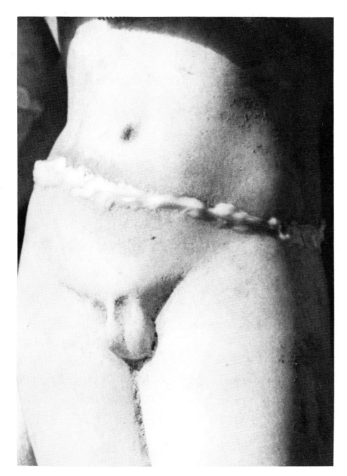

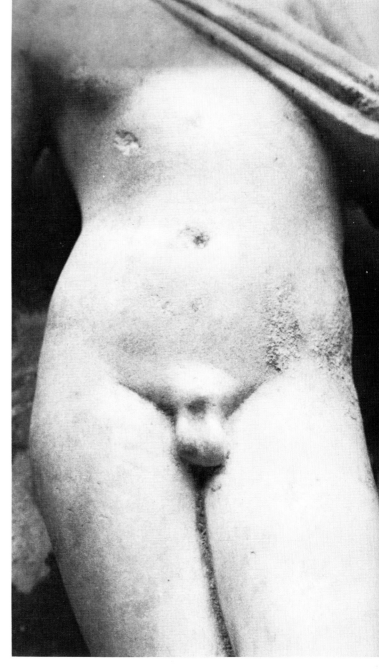

37/38
Invisible retouching on a classical white marble. This can be achieved only with the aid of faked chalk deposits.

sold in tubes. The enormous variety of effects he needs, from the brilliance of enamel to an almost powdery mat quality, is such that he prefers to start with powdered pigment and mix it himself with all kinds of mediums (gloss or mat varnishes, various adhesives, etc.). He can produce opaque tints, dense tints, with smooth or granular textures, depending on his proportions of whiting, coloured pigments, mediums, and on the way in which the paint is applied. He can create transparent tints that, laid one on top of another, will form what is called a glaze, an effect of deep and delicate resonance.

When retouching, the restorer uses all the pigments that his skill and imagination suggest. He has a whole collection of earths of varying degrees of antiquity gathered from their natural resting-place – ochre, white, or pink earths that will clothe his repair in a final veil of dust or, mixed up with glue, imitate those chalk deposits that so often occur on classical marbles. It would take too long to enumerate here all the materials – and some of them are quite mysterious – that the restorer uses for the purposes of retouching.

To make a good job of it he must first analyse very closely the material he is trying to imitate. He must be aware of the part played in it by various shades of colour. A piece of limestone, for example, will call for an opaque off-white with a transparent scumble soiling the surface; on top of this he may add spots, dirty marks or polychromy. A light waxing may be essential as a finishing touch.

As a general rule, the restorer always starts with an opaque ground tint that is too light, soiling it gradually with scumbles. One of the mistakes most commonly made is trying to hit the right tint straight off. The result is invariably a heavy, opaque effect.

The way the paint is applied will also vary enormously. A medium-soft brush leaves hair marks in an opaque, glue-based paint; this may have to be rubbed down when dry to get it quite smooth. A thick tint may also dry rough if it is fitched on with a hard brush; this is how one retouches limestone and terracotta. For soiling a colour or applying a transparent glaze the restorer uses a brush of pole-cat-hair, a large, very soft brush that hardly leaves any marks. A light glaze can also be spattered on with a very hard brush, or the restorer may even use a cotton-wool swab or a deliberately dirty hand. The colour of certain types of stone is a product not of several superimposed tints but of the juxtaposition of tiny spots of different colours (ills. 34–5). This is true of sandstone, for example, whether Khmer, Indian, or Western, and the technique known as spatter-work – a favourite with children – is exceptionally successful when it comes to retouching sandstone sculpture. The restorer takes a perfectly ordinary paint-brush and crops the hairs to half their length to make them stiffer. This gives him a very cheap "spray gun" with which he can project a series of rubber-varnish-based paint mixtures in the form of tiny dots (ill. 36). He first analyses very closely the skin or surface to be imitated and then makes up a palette of four or five different tonalities. If he embarks on a whole series of retouching jobs of the same type, he may soon find himself commanding an enormous, indeed an almost infinite variety of shades. The spatter method of applying tints and glazes comes in handy whenever one needs to lay down a very fine mist, juxtapose colours that must not mix, or make a piece of retouching fade away at the edges of the filling.

This idea of fading away imperceptibly onto the authentic portion is the key to invisible retouching. We have seen already that the simplest method of concealing repairs would be to repaint the piece of sculpture all over. But without going to this extreme, even the most skilful restorer is obliged to paint over a little of the authentic portion. The object is to allow the eye to pass right across the filled area without detecting it, and the thickness of one's retouched paint layer, which is normal on the portion that has been renewed, diminishes to nothing on the surrounding original so that the eye shall not get a shock as it switches from the fake to the genuine. Where this principle really counts is when the restorer is retouching a repair to white marble. If his translucent filling fails to give the desired result and he has to retouch, he will have the supremely difficult task of achieving a gentle transition from the transparency of the marble to the opacity of his paint and back again to transparency. On classical fragments (ills. 37 and 38) one may be saved by deposits of red earth, chalk stones, or clouding of the surface of the marble, and be able to get away with a fairly summary repair – for example, a groove in which one deposits a little of the red earth. But on an eighteenth-century bust that is perfectly white and smooth, a great deal of skill will be required to conceal any repairs. The restorer must first make an absolutely perfect opaque filling using whiting and glue, and then spray it with a little of the same whiting, absolutely clean, mixed up with a small quantity of methacrylate varnish; this tint will be delicately rubbed down

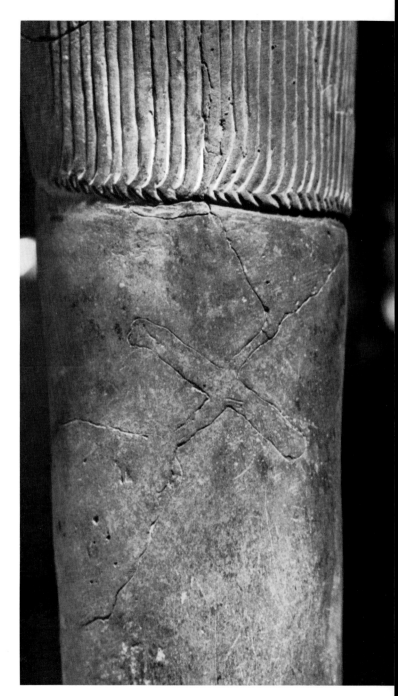

39
A restoration formula much favoured by museums: the repair is retouched for invisibility and then outlined with a graver.

and a second coat sprayed on to fade away on the original marble.

VISIBLE RETOUCHING

Aesthetically difficult but technically simpler, the process of visible or "museum" retouching consists in repainting in a tint that is different from or close to the rest of the work, and confining one's attentions exclusively to the renewed portion.

This type of retouching assumes enormous importance in the restoration of any kind of painted surface such as a painting, fresco, or a piece of pottery, but it has little place in the restoration of sculpture, where the question of honesty relates more to volume than to colour or pattern. The candour required of museographical restoration will consequently be expressed more in a refusal to reconstitute or in a recessed filling rather than in terms of the way the piece is retouched.

If one is going to renew missing material one should retouch the repair in such a way that it is brought as close as possible to the rest of the piece. It would be a betrayal of the spirit of the work if a "bracelet" around a fractured wrist or the mass of a reconstituted breast were deliberately left visible.

Honesty will be better served by an engraved line neatly defining the repair; the repair itself should be retouched to perfection (ill. 39).

Visible retouching on white marble is, as we have seen, in the nature of an intellectual ruse, disguising the impossibility of making a good, discreet job of invisible retouching. Here the restorer will confine himself to a first-class filling clearly outlined and correct it in water-colour only.

WOOD SCULPTURE

What a glorious, living material wood is – light, delicate, easy to work, capable of being polished, waxed, painted or gilded, and with a texture that has something almost mystical about it, when what was once a tree becomes a human figure!

But how much is left of the wooden sculpture of bygone civilizations? Three chests from Angkor Vat bear witness to an art that, even in its stone architecture, drew much of its inspiration from the techniques of wood-carving. Only the deserts of Egypt and Peru and the frozen wastes of Siberia have succeeded in preserving their perishable masterpieces into our own day.

Anyone visiting the churches of Brittany during the winter months will receive a vivid impression of the destruction wrought by damp, worm and fungus on a material that has been employed universally by sculptors down the ages. Our own era, with its great interest in the art of the past, must not allow this heritage to go to rack and ruin, particularly when modern restoration techniques are capable of achieving spectacular results.

Stripping and cleaning

STRIPPING POLYCHROME STATUES

We should not be too hard on the clergy's habit of going over the church statuary with a paint-brush every couple of hundred years. The great merit of these multiple coats of paint – gaudy at first, changing to grey in the nineteenth century – is that they have kept a large number of wooden statues in pretty good shape.

There is nothing more exciting than setting out to explore a wood-carving that is potentially four-teenth-century but looks in its present state like the crudest kind of plaster-cast "holy figure". One is progressively more astounded at the delicacy of the original colouring, the firmness of form and detail revealed beneath the clumsy layers of overpaint. Often one finds oneself participating in a veritable resurrection (ill. 40). Many dealers, unwilling to go to the expense of restoring polychrome statues to their original state, sell them stripped down to the bare wood and thus deprived of much of their true nature. Apart from having lost its colour, the carving underneath will have a (deliberately) dry, abrupt quality since it was designed to be seen not in the bare state but with the softening effect of a ground and paint layer. The conscientious restorer always tries to preserve a work's original paint, even if only traces of this remain.

How does he set about it?

Dry stripping

He always starts by trying to remove the overpaint without the aid of paint stripper. If the attempt is successful, the tints exposed will be fresher and the piece will show less sign of having been interfered with. Dry stripping is done with sharp tools of a suitable shape to follow the contours of the piece of sculpture. A scraper made out of an old triangular file comes in very handy; so do a medium-sized wood chisel and two or three gouges. But the restorer will usually find himself needing another

40
Stripping the paint from a fourteenth-century *Madonna and Child*. Compare the delicacy of the original colouring with the ponderous blue overpaint. A great many repairs will be necessary here.

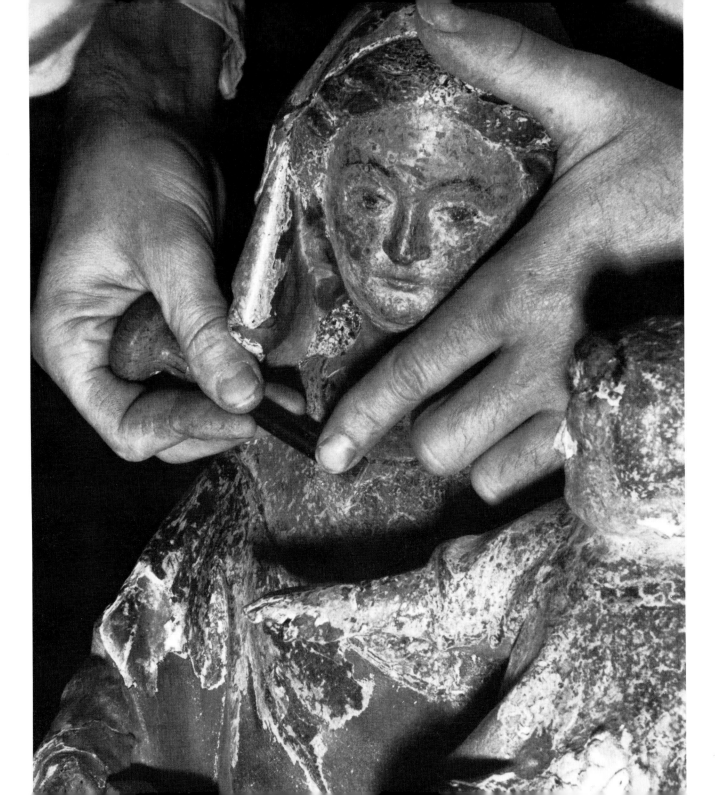

piece of equipment – namely inexhaustible patience. He starts with his scraper or gouge on a small area, if possible one that is tucked away out of sight, and on the basis of this initial contact he is able to work out a technique to suit the particular – and it always is particular – case in hand. Are all the coats of paint going to chip away from the bare wood in one piece? If so, the restorer must first consolidate. Will the coats of overpaint need scraping off individually or can he, by using his tools in a particular way, lift them away from the original polychrome work in flakes? It is essential to remain flexible, adapting a variety of techniques to fit the case, and to have a very firm idea, right from the outset, of what one wants to achieve, i.e. to preserve as much as possible of the original paint layer.

It is difficult to explain in words the correct grip for holding a paint-stripping tool. It is something one can really only demonstrate. But this much can and must be said: the hand holding the tool and applying pressure to the paint to be removed *must* rest on the object, with only the fingers moving (ill. 41). This cramps one's style to some extent but is the only way to combine strength and precision.

How does the restorer recognize the original polychrome and avoid stripping beyond it to the ground or even down to the bare wood?

Well, for one thing it will be very close to the surface of the wood, and for another thing it will be vastly superior in quality to any subsequent overpainting, which will invariably have been done by amateurs.

41
Dry stripping. Two fingers of the left hand give both firmness and delicacy of touch.

This quality will immediately strike any restorer equipped with taste and with a clear idea of the kind of colouring he can expect to find, given a statue's date and place of origin.

The original paint layer is always delicate and smooth and was often applied to a ground. Instead of it being uniform and flat in tonality, variations in thickness and in the concentration of medium make it vibrate subtly between strong and pastel shades. Also its surface is often covered with a fine network of craquelure.

The restorer may also find himself assisted in his task by the usually careless approach of the person who gave the piece of sculpture its first coat of overpaint. More often than not this amateur painter will have omitted to clean the work before repainting it, dirt and grease will have impaired the adhesion of his paint, and the restorer may be treated to the rewarding experience of seeing it and all the paint added subsequently come away from the original paint layer in nice clean flakes.

Even so, it is very difficult to get rid of this penultimate coat completely, and many restorers are content to leave a pleasant pointillist blend of traces of several superimposed coats and patches of bare wood. Though occasionally pretty, this effect is never of course authentic.

Chemical stripping
If dry stripping fails, however, the restorer must resort to using a chemical paint stripper.

It may be that the various coats of overpaint have formed a thick crust that cannot keep up with the shrinkage of the wood; like an over-large garment, it separates from the surface of the statue, taking the original paint layer with it. Dry stripping would

have it all coming off like autumn leaves. So the restorer begins by consolidating the polychrome, seeking to reattach it to the wood by introducing vinyl adhesive (see the section *Consolidating polychrome*); then he softens the more recent paint with a chemical stripper, after which it will scrape away easily. (There are all sorts of paint stripper available; this book being aimed at the general public, I would recommend the ordinary paste stripper that you can buy in the shops, provided that it is guaranteed potassium-free.)

The danger, of course, is that the original polychrome paint layer that one is trying to preserve will be softened and destroyed too. Although old paintwork is more resistant to stripper than more recent coats, the process of chemical stripping calls for a great deal of discipline and skill. The worst mistake the restorer can make is to cover the entire piece with stripper; he will soon find himself wrestling with a terrible mess of softened paint, ruining the original polychrome and the overall harmony of the work. He must restrain his natural impatience to discover what lies beneath the overpaint and resist the temptation to regard chemical paint stripper as some kind of miracle weapon. Confining himself to an area not more than ten centimetres square, he brushes on an even coat of stripper between two and three millimetres thick. He then waits patiently for up to a quarter of an hour while the paint stripper does its work, resisting the further temptation to spend this time covering other areas. He then attacks the softened surface with a slightly sharpened spatula, carefully wiping off each gob of paint with a rag rather than simply pushing it in front of him. Common sense dictates an extremely methodical alternation of stripper application and scraping

– and as much cleanliness as possible in what is essentially a very dirty job.

A coat of stripper should never attack more than one or two coats of paint (ill. 42). The thinner the coat of stripper, the less deep it will "bite". It may be necessary to repeat the operation as many times as there are coats of paint to be removed, but at least one will be sure of stopping short of the original polychrome.

Apart from this general recommendation as to method, one can only advise the restorer not to change his brand of stripper and to explore thoroughly its potential in dealing with the infinite variety of paints in terms of composition, solidity, age, adherence to the wood, etc. Should he, for example, attack the paint only after a full quarter of an hour or after as little as three minutes? Should he use a very sharp tool, a spatula, or simply a cotton rag? A method may be quite wrong in one case and give excellent results in another. But what matters more than the method is that the restorer should master it completely. The trouble with chemical stripper is that one can so easily get carried away. Whichever method his preliminary trials suggest – i.e. dry stripping or chemical stripping – the restorer must bear in mind that uncovering the original polychrome on a wood or stone statue is invariably very finicking, very slow work; it really is like removing a speck from a butterfly's wing. People speak with respect of restorers of drawings who can take a piece of paper with drawings on both sides

42
This photograph shows the different coats of paint covering the original polychrome work. We can just see the edge of a garment that was not redone in the more recent coats.

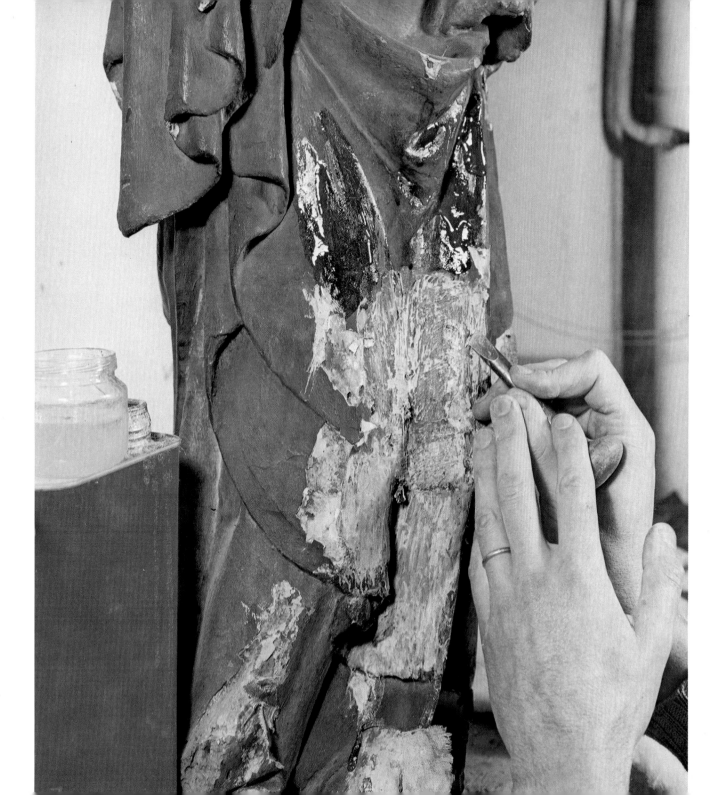

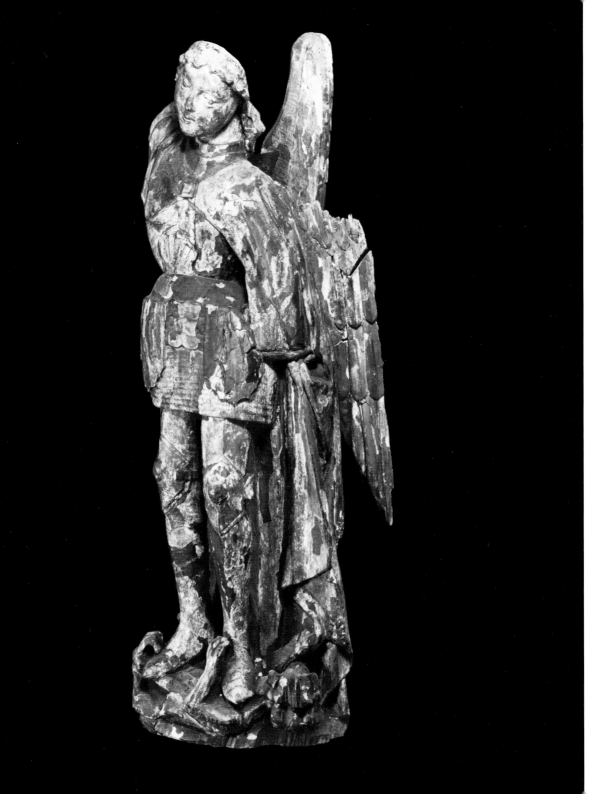

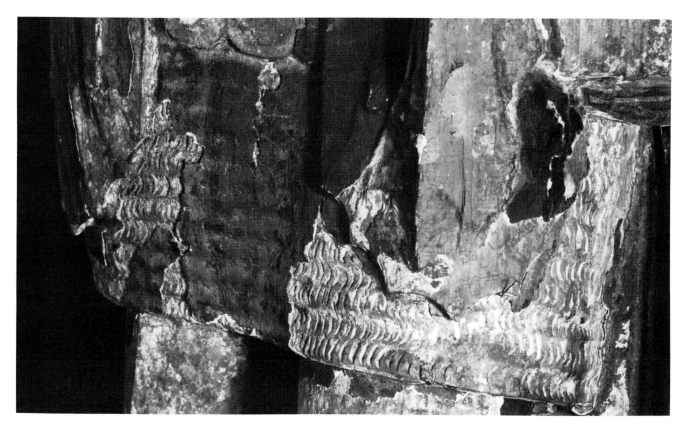

44
Detail. The thick paint obscures the carving of the garment.

and actually slit it in two; the work of paint stripping, if the restorer goes about it properly, is just about as delicate. Here the amateur can often do a very much better job than the professional, who can never afford the time to be quite as meticulous as he is expected to be. As far as stripping polychrome statues is concerned, private-enterprise restoration

43
◀ This *St. Michael* was originally unpainted. The badly flaking paint destroys its harmony and renders the work illegible.

will never produce ideal results. It is essential to break the time/money connection and set up small teams of state-supported restorers, whose status would spare them the agony of the exceeded estimate and allow them to think in terms of stripping square millimetres rather than decimetres.

STRIPPING NON-POLYCHROMED WOOD

One occasionally comes across pieces of woodcarving – choir stalls, doors, etc. – that were originally unpainted but have subsequently been covered with a number of coats of paint or varnish, gener-

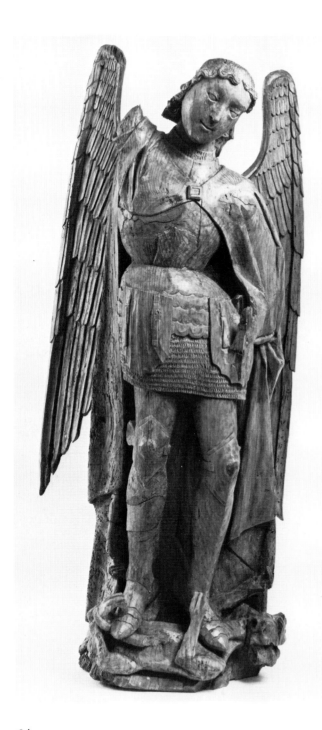

ally seeking to imitate wood and intended to protect the work from the weather or disguise hideous putty fillings. Apart from the depressing colours used for this type of botching, the paint clogs up the hollows and obscures the delicacy of the carving. Today we can and should get rid of these unsightly carapaces (ills. 43–5).

This operation is infinitely easier than the last, once one is sure that there is no original polychrome to be preserved.

It is tempting, particularly on a large work, to use potassium, either in a bath or in the form of a compress. Potassium will destroy any kind of paint very easily in a single night; unfortunately it has the effect of turning wood black, and anyway leaving wood in a bath all night has never been a very good idea. If dry stripping fails, the restorer is best advised to keep to a potassium-free stripper, as before, although he can use it more liberally than when uncovering original polychrome.

The softened paint is removed with a scraper, spatula, or knife capable of following the contours of the work rather than with the lazy man's tool, the wire brush, which is of course very much faster. A potassium-free paint stripper will leave the natural colour of the wood unimpaired, and a simple brush-down and a coat of virgin wax will restore life to the surface. It will not matter if a little paint is left in the pores of the wood; the important thing is to have recovered the delicacy of the carving.

45
All the paint has been removed and the decoration has reappeared. The wing has been repaired in the same wood, restoring the rhythm of the statue. It was not considered essential to renew the arm, which would have called for guess-work and invention.

Cleaning

CLEANING ORIGINAL POLYCHROME

Not all old polychromes were daubed with gaudy colours or with the uniform grey of the nineteenth century, and any that have survived will undoubtedly need cleaning. This may present difficulties if the grime is deeply ingrained in the paint.

First of all the restorer must check that the polychrome stands up to water; then he prepares a solution of soft soap boiled in water, containing a dash of alkali. The statue is cleaned with wads of cotton-wool dipped in the solution, each wad being thrown away as soon as it is too dirty.

If he is to achieve a satisfactory overall balance, i.e. the same degree of cleanness all over the statue, the restorer must work fast, stand back at regular intervals to look at the work as a whole, and afterwards rub down once more all the bits that are still too dirty.

When the job is finished, it may be necessary to resoil a place that is too clean in relation to another with a light water-colour tint. A polish with virgin wax will complete the process. The wax can be applied dry: by rubbing a cake of wax vigorously with a soft brush one can pick up enough wax to give the paint the right delicate gloss.

The alkali quantity needs to be judged carefully. Too much of it in the soap solution may eat into the polychrome. It is best to make a test without alkali, continuing without it if the test is successful and, if not, adding a little at a time until it begins to work.

CLEANING BARE WOOD

Many wood-carvings, having long ago lost all their polychrome or never having been painted in the first place, have either been left to the ravages of time or have, on the contrary, been all too lovingly fussed over and kept waxed as if they were so many pieces of furniture. In both cases what the restorer needs to do today is to give them back something of their natural freshness.

Where darkening of the wood is obviously due to dirt having accumulated in the pores, it will pay the restorer to use oxalic acid (or salts of sorrel), obtainable from any cabinet-makers' supplier. The crystals are dissolved in four times their volume of water, and the best method of cleaning is generally to use a cotton-wool swab. When dry, the surface of the wood may show a faint whitish mist. This can be got rid of by brushing and by applying an infinitesimal coat of wax.

On the other hand loving attention of the wrong kind may have brought about a serious imbalance of volumes that disturbs the whole spirit of the piece. For example, a statue – of walnut or oak – has been meticulously polished every week; the woodworm holes are all neatly plugged with tinted wax, the tannin in the wood has combined with the dusty coats of wax to make the surface very dark, the pores of the wood are stopped up, there is a film between us and the object, and we begin to wonder whether we are in fact looking at bare wood or at painted wood. Once he has got rid of all this chocolate the restorer may find a mat, blond wood that will do justice to the volumes and to the highlights and shadows of what could turn out to be the masterpiece of an important school of medieval sculpture.

It is a major operation and a radical one. Often the only way of extracting old wax and bleaching wood that has been darkened by the tannin rising to the

surface is to use a fairly violent method that is not as easy to control as cleaning with a cotton-wool swab. The restorer must be familiar with all the tricks that will subsequently make good what at first sight may appear to be a disaster.

As always, he will start with the gentle method, trying to dissolve the wax with one of his usual solvents, namely xylene, which is more powerful than oil of turpentine. Experience shows, however, that this solvent is ineffective against wax that is several centuries old, and too often the restorer will have to resort to the harsh method of cleaning and bleaching wood; he will have to use peroxide of hydrogen. This only works in conjunction with the right amount of alkali (there is presumably no need to point out that this operation is to be performed out of doors!). One method is to cover the whole piece of sculpture with alkali and then apply peroxide of hydrogen with a nylon brush. Another method consists in mixing the two ingredients in a glass vessel and applying the mixture with a cotton-wool swab wound round a stick. The reaction on the wood, dirt and wax is extremely violent; a great deal of foam is generated, which drives the wax out of the wood. The operation is repeated once or twice, and the piece is then rinsed very thoroughly. The result looks like new; the veins reappear, and the light once more plays on the pale surface of the wood.

There is, however, a great risk of the technique being too effective in some places and not enough in others. This will create a serious colour imbalance, depending on the quality of the wood, and in particular it will throw the knots into relief, since these will never bleach as much as the sap-wood. The piece will almost always need to be rebalanced by restaining the parts that have gone too pale. It is unnecessary as well as dangerous to use the whole palette of stains employed in the cabinet-making trade. The only colour permissible – and it always gives excellent results – is a decoction of chicory (which has the added advantage of being easily made: you simply boil some chicory in water). It is not always easy to make this staining look exactly right.

The peroxide technique must always be considered as a last resort, only to be used when oxalic acid and xylene have failed and the experienced restorer feels intuitively that an important discovery is at stake, in other words that the qualities of the piece of sculpture will be dramatically enhanced. The method is best avoided altogether by anyone who lacks a precise conception on the one hand of what he expects to achieve and on the other hand of the various ways and means of getting out of what may sometimes be a tricky situation.

REMOVING OLD REPAIRS

Cursory examination of a wooden statue will often reveal old and rather ugly repairs – worm-eaten portions that have been renewed and splits that have been crudely filled with plaster or cement that makes only a half-hearted and very approximative attempt to reconstitute the original volumes of the piece.

There is no prescribed technique for removing these poor-quality repairs; common sense will soon

46
Lyctus brunneus and the entrance to the galleries bored by these wood-eating insects.

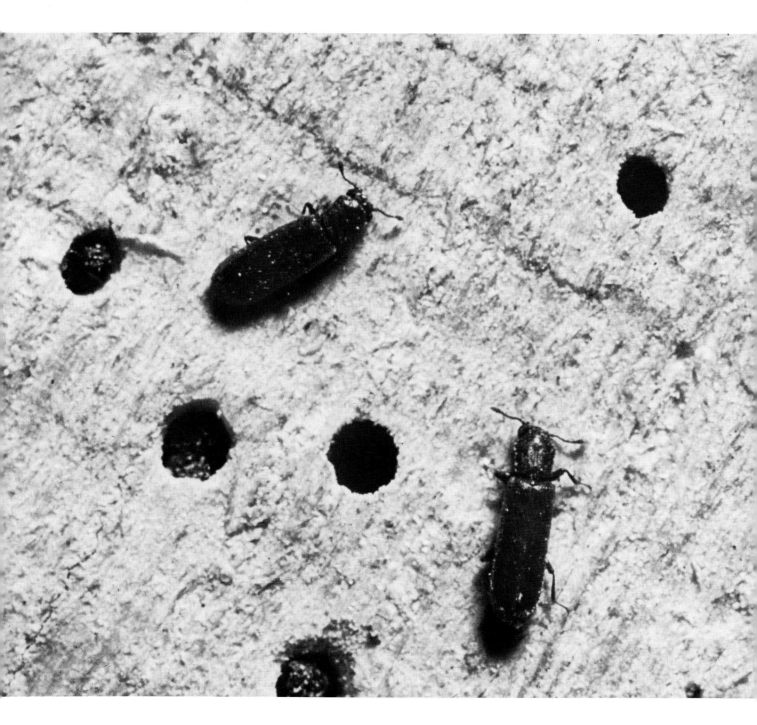

67

suggest which method is best. But removed they must be. Our modern predilection for the fragment greatly prefers a slightly worm-damaged fold of clothing to a doughy piece of modelling that wrecks the overall rhythm of the piece. We would rather have no hand at all and let our imagination reconstitute it than have to look at the stiff replacement made in the nineteenth century by the village carpenter. If filling or reconstitution are necessary, we can make a much better job of them today.

Let all these botched repairs go the way of the old wax and the gaudy overpaint. Let's clear the decks! Let us for the moment retain only what is authentic and take a long, cool look before making the least little reconstitution (for reasons that I have already explained in Chapter One, pp. 42).

Treatment

Wood, as we have seen, is an eminently edible, eminently destructible material, and works executed in it fall a prey over the years to rot, fungi and wood-eating insects (ill. 46), which carry out their depredations either in the mature (termites) or immature state (larvae of the capricorn, powder-post, death-watch beetle, etc.). Our piece of sculpture, which has to some extent survived this combined onslaught, has been stripped, cleaned, and rid of all the ugly repairs that disfigured it; it now needs to be first disinfected and then consolidated (although in cases of extreme fragility consolidation must come before the cleaning process).

Even wood-eating insects need to drink as they eat, and we find that this universal law once again throws into relief the enormous difference between museum restoration work and the on-site restoration of historical monuments.

Keeping a piece of wooden sculpture in a museum or glass case with a properly controlled climate is enough in itself to preserve it; in this case one need only destroy the wood-eating insects and can forget about preventive treatment. It is very different when the location is a damp, cold church heated only for a few hours on Sunday (a climate alteration, incidentally, that has its own disadvantages). One could of course remove all wooden statuary from churches and stack it up in air-conditioned storerooms or museums, but a *Virgin* that looks delightful tucked away in a little chapel would undoubtedly take on a forlorn and mediocre look in a museum, where the visitor's eye is after different qualities. As for air-conditioning our churches, the mind boggles at the expense that would be involved in heating and controlling the humidity in the thousands upon thousands of religious buildings dotted all over the West.

The laboratories investigating this problem in different countries therefore start from the principle that it is impossible to alter the conservation environment. Instead they spend their time exploring ways of, on the one hand, disinfecting wood and making it inedible by injecting poisons and fungicides, and on the other hand of restoring its solidity by as it were changing its nature without changing its appearance, which involves impregnating it with one of various inert materials.

A lot of techniques have made considerable progress these last few years. We shall begin by looking at the best of those that can be practised by anyone in very simple workshop conditions, going on to discuss the latest techniques that look like opening

up an extraordinary future for the conservation of porous and fragile objects thanks to the catalytic power of gamma rays on monomers.

DISINFECTION

Wood-eating insect activity is characterized by steady enlargement of the little holes forming the entrances to the galleries bored by the larvae or insects, and by the persistent presence of what looks like very fine sawdust around the base of the statue. (Some works are so badly eaten away as to consist of virtually nothing but dust, only the paintwork retaining something of the statue's original form.)

If the work is to be kept in an air-conditioned room in a museum in future, disinfection need not be followed by preventive impregnation. The method of disinfection in this case is by fumigation.

A number of laboratories are equipped with airtight chambers in which the insects or larvae can be destroyed by replacing the air in the chamber with an insecticide gas such as hydrogen cyanide, methyl bromide, carbon disulphide or ethylene oxide.

The less well-equipped restorer, assuming he does not want to impregnate the piece with some product or other, can achieve excellent results with the following simple method:

The piece to be treated is placed in a large polythene bag together with a vessel which contains a good quantity of cotton-wool soaked in commercial Xylophène. Sealing the bag, the restorer leaves the two together for a period of about a month. (This must be done in spring, incidentally.) Xylophène is usually applied or used for impregnating, as we shall see, but where the disinfected piece is to be kept in a dry, healthy climate Xylophène should be used in gaseous form as above.

In many cases where the piece is to be replaced in its former damp environment, disinfection will have to be followed up by preventive treatment. Impregnation with Xylophène gives excellent protection for many years. The statue can be impregnated by soaking it in a tank, but this is only viable when the operation is being carried out on a large scale. If only one piece is being treated, although the experts say that simply brushing on the chemical gives adequate protection by poisoning the insects or larvae as soon as they move to the surface, the restorer keeps to the classic, meticulous method of injecting Xylophène into every single gallery with a hypodermic syringe, particularly when he is dealing with polychrome statues but also as a precaution on other types of work.

Xylophène and its equivalents have the disadvantage of staining wood slightly, which may be undesirable in the case of particularly fresh polychrome or wood that is particularly light in colour. It is possible to lighten the surface, i.e. the part the eye sees, with xylene or acetone.

CONSOLIDATION

Take a look at a *Buddha* from south-east Asia that has been attacked by termites. Termites make a very good job of this sort of thing; they are neat and methodical. Where they have been at work there is nothing left except possibly a coat of paint covering a vast, hollowed-out space. Elsewhere the wood is sound and solid and no consolidation is either necessary or possible. In this case the only thing that can be done is to fill the cavity.

Most western wood-eating insects operate in quite a different way. Patiently, meticulously, they work over virtually the whole piece, boring their galleries

in the softer sap-wood at first but eventually extending their activities to the heart, gradually turning the entire statue into an airy, brittle sponge. Only at a very advanced stage does the piece become so fragile as to start losing its form; the base crumbles away and the face disappears. At any time up until then the piece can be consolidated by reconstituting the missing wood (i.e. filling the galleries) by process of impregnation. Recent advances in physics and chemistry have come close to beating the kind of problems involved here.

The restorer's choice of consolidating agent will be governed by three major considerations:

– First and foremost the colour of the statue or at least of its surface (the part one sees) must be modified as little as possible. Some very thick agents keep their damp colour, which is highly detrimental to polychromes, tending to make their vibrant tones dull and heavy, as well as to certain types of wood with a particularly attractive, luminous look that after consolidation becomes slightly tarry. The ideal is a colourless product that has a very low refractive index (in order to leave the paint colour unaffected) or that can be made to disappear by treating the surface with solvent.

– Second, the wood and any coating must not be altered in any way by the consolidating agent. The agent must neither dissolve polychrome nor swell and shrink in such a way as to warp or split the wood. The restorer looks for a very homogeneous agent with indices of expansion close to those of the wood he is treating.

– Third, the consolidating agent must itself provide protection against fungi, bacteria, insects, and against humidity exchanges between the wood and the surrounding atmosphere.

Is there a product that anyone can use easily and that combines all these qualities?

The principle underlying the consolidation process is to "fill the sponge", in other words to replace the void represented by the galleries with an agent that is hard enough to maintain the form of the piece on a permanent basis. To make this solid body penetrate the piece we need a vehicle, i.e. a solvent that will carry it to the heart of the wood and subsequently disappear by evaporation, leaving the consolidating agent where it is needed. It is impossible to fill the holes in worm-eaten wood completely by this method since the liquid used will lose about ninety per cent of its volume by evaporation. One only consolidates the walls of the galleries – almost as if one were consolidating lace, except that this "lace" is three-dimensional. Nevertheless the principle is often satisfactory and represents the only practicable method for the ordinary restorer, even if he has the resources of a restoration studio.

Every restorer has his pet consolidating agent. Two very good ones available in France are Araldite, an epoxy resin, dissolved (twenty per cent) in trichlorethylene, and Paraloid B 72, a copolymer of acrylate and methacrylate, dissolved in xylene or toluene (twenty to thirty per cent resin). The first has the advantage of combining with an effective solvent, namely trichlorethylene, that is readily available; it stays flexible, and its great adhesive power makes it an excellent consolidating agent. The second is a copolymer from the same family as plexiglas and has the advantage of not yellowing with age.

Using either of these two products, the restorer impregnates the wood to saturation point either by

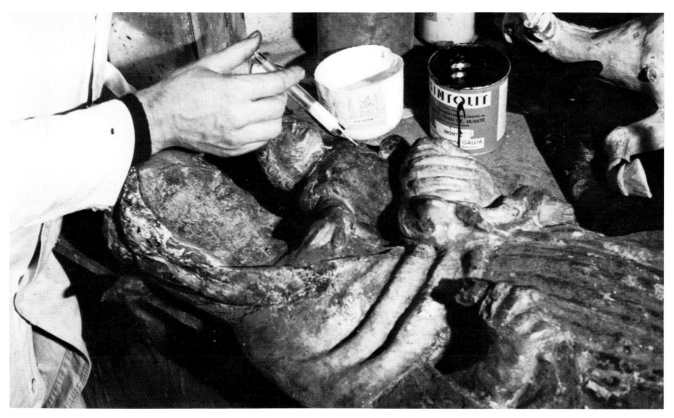

47
Syringe injection of Paraloid B72 on a badly worm-eaten statue.

immersion (often too costly), or by injection with a hypodermic syringe (ill. 47), or by dripping the agent on with a brush. Before it dries the surface must be carefully wiped with a swab dipped in solvent. The gloss on dry Paraloid can be killed with toluene or xylene, whereas Araldite, which polymerizes, ceases to be soluble when set; a swab dipped in paint stripper will restore a perfect optical surface.

Whichever consolidating agent he uses, the restorer will find himself confronted with the tricky problem of the filter effect. The vehicle or solvent tends to deposit the resin prematurely in the wood dust clogging the galleries. The solvent penetrates to the heart of the piece without any difficulty but the resin builds up in the first centimetre of depth, preventing any further penetration and consolidating only the outer skin of the work.

The more slowly impregnation takes place, the deeper it will reach. The L.R.M.H., which uses Paraloid in xylene, appears to have overcome this filter problem by introducing the agent very slowly with the aid of a medical drip, as used for intravenous feeding. Hollow needles are run deep into

the affected parts, and the Paraloid B 72 is allowed to seep gently into the very heart of the statue. (The drip method is useless with Araldite, which whether dissolved or not polymerizes in a matter of hours.)

CONSOLIDATION METHODS USING GAMMA RADIATION

With the appearance on the market of polymerizable plastics capable of hardening as a mass without losing volume, restorers thought that here was a marvellous possibility of effecting better, more homogeneous, and altogether more definitive consolidations.

Unfortunately polyesters using the monomer styrene needed to be mixed with a catalyst such as cobalt octoate to make them polymerize. What happened was that the product hardened long before it had penetrated to the heart of the wood. Moreover, in hardening it gave off heat in proportion to the amount of polyester present, and there was a danger of it exploding and taking the wood with it. Also there was never time to clean the statue before it had set; statues consolidated in this way were left with a horribly syrupy, shiny look. Worse still, they felt permanently tacky because the oxygen in the air prevented the surface of the polyester from polymerizing. In short, these early attempts were not a great success, and restorers had to abandon the high hopes they had placed in polyesters.

It would have been all right if one could have taken one's time, first finding a leisurely method of inserting the polyester right to the heart of the piece (under pressure, by vacuum immersion, or by the drip method), then removing excess polyester and cleaning the statue, and only then introducing the catalyst. It looked as if there might still be possibilities, but nevertheless restorers were forced to drop polymerizable resins and keep to resins dissolved in a suitable solvent.

The answer, naturally enough, came from industrial research. A laboratory at the Grenoble Atomic Energy Research Centre was commissioned to study the feasibility of using nuclear radiation as emitted by radioactive isotopes in process of disintegration in the manufacture of new composite materials, in particular plastic wood. It was Louis de Nadaillac who first hit upon the idea of using the method on art objects. The gamma rays given off by cobalt 60 are capable of catalyzing a resin used in conjunction with a monomer by opening the double bonds of the monomer molecule, and this can be done *after* the resin has been introduced where it is needed. By 1970 preliminary trials had proved sufficiently convincing for the method to be applied to treating the wooden floor of Grenoble's old town hall. The excellent result has been confirmed by the state of the floor since; clearly it is safe for a long time to come. Since then many art objects on the verge of disintegrating have been rescued in this way, and it has been discovered that the process can also be used with success to treat crumbly stone.

How is it done?

The worm-eaten or rotten wood-carving is placed in a large cylinder measuring three metres in length, eighty centimetres in diameter (ill. 48), and carefully weighted, because we are going to submerge it in a

48
The object is placed in an air-tight container where it will be subjected to a vacuum before styrene monomer and resin are introduced.

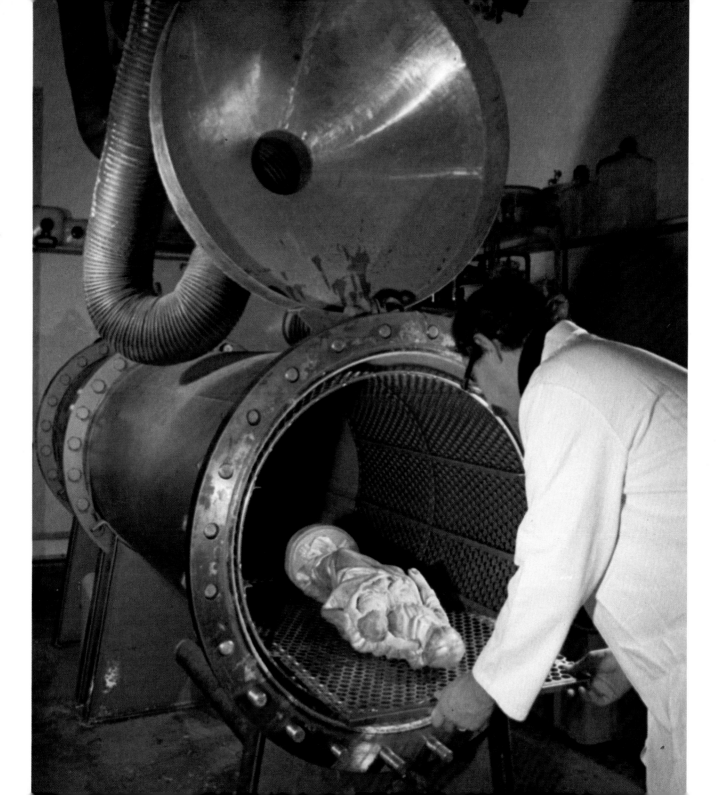

moment. The cylinder is then hermetically sealed, a vacuum-pump creating a partial vacuum in it (about one centimetre of mercury) to extract the air from the pores of the wood. A pipe shut off with a valve links the cylinder with a huge tank of consolidating agent – usually a polyester dissolved in fifty per cent of its monomer, styrene. The valve is slowly opened and the consolidating agent is forced by depression from the tank into the cylinder, where it completely submerges the piece being treated. Air is then admitted above the surface of the liquid and atmospheric pressure forces the resin into the wood. The valve is reopened and nitrogen pumped into the cylinder in order to force the unused resin back into the storage tank. (One enormous advantage of the method is that vast quantities of polyester can be used without any loss.)

The piece is removed from the cylinder and allowed to drip off for a while; afterwards it can be wiped down with a rag dipped in the styrene solvent. Evaporation of the styrene and this cleaning of the surface will restore the appearance of the statue virtually to what it was before impregnation.

The piece is then placed in the irradiation chamber (ill. 49). This is a bunker with walls more than one and a half metres thick, fitted with an observation window hardly less thick (1.4 m.). The heavy door of the chamber is closed tight, and the rods of cobalt 60 are drawn out of the bath in which all the laboratory's irradiation sources are kept beneath four metres of water. Polymerization begins, i.e. the double bonds of the styrene molecules, opened by the effect of the gamma rays, are able to hook onto the molecules of the polymer (polyester). The exothermic reaction, which makes large quantities of resin burst, can be spread out in time following a curve that can be modified at will by adjusting the proximity of the radiation source (twenty to 100 K. rad. per hour).

The piece is removed from the irradiation chamber after twenty hours, completely consolidated and sterilized as well (gamma rays, which are fatal, do not make the irradiated object radioactive). It will be appreciably heavier than before (130 per cent in the case of badly damaged wood, only twenty per cent if the wood is sound), and trial sections will show that the wood is impregnated and hardened through and through. The colour of the piece will be very slightly darker, but the change appears to be minimal in comparison with traditional consolidation methods.

Certain reservations have been voiced in responsible circles with regard to the radiation method, the chief points of criticism being as follows:

– We have too little perspective on it to risk a masterpiece.

– The increased weight (but where is the disadvantage in this?).

– Slight shrinkage, occasionally causing movement in the wood. This has in fact been established on a *Virgin*, where one arm no longer quite meets the hand carved on the breast.

49
General view of the irradiation chamber. Through the observation window we see the impregnated object and the rods of cobalt 60, which can be moved closer to or farther away from the object to control the polymerization process and the emission of heat.

– Polychrome work does not seem to get satisfactorily reattached. The treatment needs to be followed up by refixing with vinyl adhesive, as in the case of all other forms of treatment.

– Finally, accelerated-ageing tests on samples of sound wood impregnated through and through are inconclusive. While they are indispensable when it comes to comparing two methods, these tests are not an exact reflection of reality; a month of alternate hot and cold, damp and dry conditions is no substitute for a century of damp in the crypt of a church (nor would you put twenty years on a car simply by running it into a tree). On the other hand the test sample used is a piece of sound wood that has virtually lost its directional properties; it has become incapable of standing up to the plastic impregnating it.

Of course it is the duty of those responsible to counsel prudence and to ask that research and experimentation should first make the process wholly reliable – but a large part of our artistic heritage is in jeopardy right now.
Masterpieces are no problem; restorers will always find the time to consolidate them on a piecemeal basis, and if they remain fragile they can always be kept in the same kind of glass cases as butterflies. But there is an army of wooden saints being decimated every winter. Not all of them are masterpieces, but they bear witness to a particular period

50
Consolidating polychrome work by infiltrating polyvinyl acetate adhesive.

of human history, as much by their abundance as by their naiveté.

CONSOLIDATING POLYCHROME

We have seen that even the latest techniques are incapable of completely reattaching polychrome work that has started to come away from the wood. This is one of the stumbling blocks of restoration. A flaking oil-painting can be refixed to its support because canvas is a permeable material and adhesive can be introduced through it from behind. A wooden panel painting can be transferred to a new support without losing any of its interest. When one is dealing with a polychrome statue, however, there can obviously be no question of removing the original support. One can only work from outside, and one cannot hope to make a completely satisfactory job of it.

One's first instinct, perhaps, is to varnish the statue – as if to enclose everything in a transparent bag. The restorer knows that this in fact only accelerates the damage, with the varnish literally pulling the flaking paint layer off the wood.

So the only remedy is to use polyvinyl acetate adhesive mixed with warm water and a little photographic absorptive. Large drops of adhesive are allowed to drip off a brush onto all the places where the paint layer exposes the bare wood and allowed to seep in between the two. It is best to go over each place several times (ill. 50). The water has the effect of softening the ground, which allows the paint layer to flatten down and readhere to the wood – that is, where it had begun to flake; where it is still intact one can only sit back and wait for the flaking process to start of its own accord, which is not of course much comfort.

Repairing wooden sculpture

REFIXING FRAGMENTS

If the piece of sculpture is in a really bad way, i.e. reduced to a crumbly, spongy state and broken into several fragments, it may not be possible to glue it before consolidation. In this case each fragment is consolidated separately and the piece is reassembled afterwards. Wherever possible, though, all gluing should be done before consolidation treatment, particularly when this is to be done in a vacuum and using gamma radiation.

The process is similar to that involved in repairing stonework but is made easier by the relative lightness of wood and by its tremendous receptiveness to adhesive. Nevertheless the choice between simply gluing and gluing with dowel-pins will again depend on the ratio between mass of fragment and area of fracture.

The kind of problem that may arise in gluing fragments of wood together will be due to the directional and fibrous properties of wood and the resultant complexity of the fractures, in which broken wood fibres may prevent the fragments from knitting together properly. The restorer must fit the fragments together experimentally without adhesive, note where the offending fibres occur, and remove them with a chisel. The best adhesive here is the epoxy resin Araldite, which is ideally suited to use on wood and has the great advantage of polymerizing without shrinkage, which means that it will plug any gaps in a poor fracture.

If dowelling is necessary – for example, to refix an arm or a leg – the restorer chooses wooden dowel-pins, drills his holes with a minimum of play, and makes his Araldite slightly thixotropic with silica

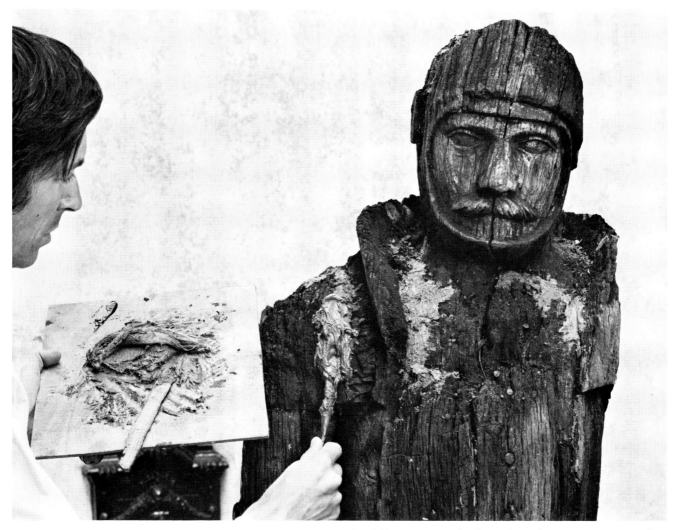

51
The larger lacunae on this statue are filled with highly adhesive Araldite putty.

gel in order to stop it running. The broken member is held in place while the Araldite sets with anything and everything lying to hand: string, rubber bands, clamps, sticky tape, etc. After gluing and before the

Araldite sets – which it does best in a warm, dry atmosphere – the restorer carefully wipes off any excess adhesive with trichlorethylene.

RENEWING MISSING MATERIAL
It is not always necessary to fill up a hole caused by worm damage or rot. We came across this problem in Chapter One in connection with stone.

It is a question of taste and judgement. If our modern age has, possibly through force of circumstances, grown used to and even developed a certain liking for the fragmentary, this is particularly so as far as worm-eaten wooden sculpture is concerned, where any amputations are less offensive for being less precise. We prefer every time a statue on which the bottom of the robe tails off and disappears in an indistinct mass of ruined wood to one with too much clumsy renewal work done in some synthetic material that, however skilfully used, will never achieve the texture of wood. Here again the restorer must stand back and look at the piece through half-closed eyes, seeing it as a whole and only repairing such accidents as rudely disturb its overall harmony and balance. A tiny hole may throw an extremely awkward shadow; a larger missing portion may best be left for the imagination to recreate.

If, however, it is necessary to fill a hole – say one of those large, irregular, spongy cavities – it must never be done with another piece of wood (as one would mend a piece of furniture, for example). This would mean squaring off the cavity in order to fit the new block of wood, and one's restoration job would no longer qualify as reversible. Wood is reserved for the renewal of complete elements – hands, angels' wings, pilgrims' staffs, etc. (ill. 45). For a long time restorers used stucco, a mixture of plaster and glue that offers great advantages when it comes to retouching, as we shall see. The trouble is, the wood continues to lead its own life and the stucco, which is of course inert, eventually comes away from the hole, taking some of the worm-eaten wood with it.

Nowadays we have Araldite putty, a material that was originally developed by the automobile indus-

52
After polymerization, Araldite putty offers all the advantages of wood and can be worked in the same way with chisel and gouge.

try to make small replicas of new models with which to study their aerodynamics. This putty, which sets only after being mixed with its hardener, remains slightly flexible, has enormous adhesive power (which can be further boosted with a coat of pure Araldite), and above all can be worked exactly like a soft-wood, i.e. with chisel, gouge, rasp, abrasive paper, and so on (ills. 51 and 52). It is the ideal material for reconstituting missing portions to the same strength as the original.

Unfortunately Araldite putty is very much less ideal when it comes to retouching. Its deep violet colour is difficult to modify with pigments, and part of the

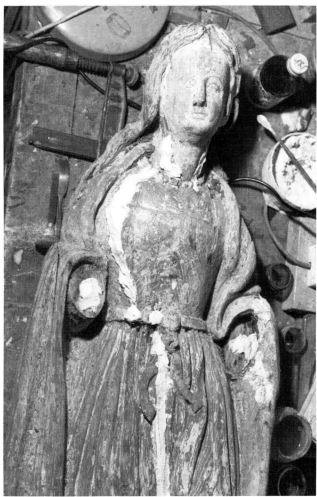

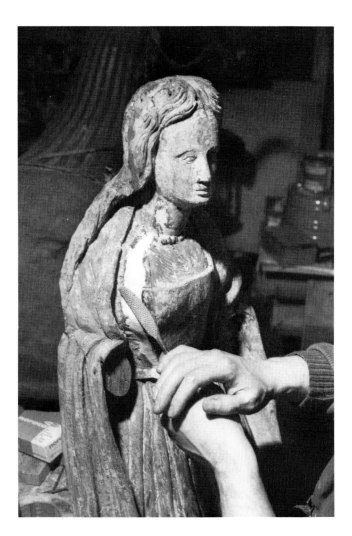

53
This unpainted wooden statue has a long split. This is almost filled with Araldite putty and topped off with a very pale stucco that can be retouched with transparent tints to imitate the wood.

54
When set, the stucco is worked with a riffler.

charge tends to migrate through the retouching paint layer. A good solution on light-coloured woods and polychromes is to fill the hole up to within about a centimetre of the surface, completing the filling with untinted stucco; a bit of polyvinyl acetate adhesive will provide a good bond between the stucco and the hardened Araldite putty underneath (ills. 53 and 54). After setting – but before it is

completely dry – the stucco can be roughed down with a gradine. Once it is dry it can be finished off with riffler and graver and made to imitate the veins and accidents of the original wood (ills. 55 and 56). If the wood is very dark, Araldite putty can be used for the whole filling and the surface adjusted with bitumen, shellac varnish and powdered pigments. One may have occasion, when restoring a wooden statue, to renew some more important element such as a hand, foot, or angel's wing. For example, the amputation may be due not to general wear and tear but to a sudden accident to a piece that is otherwise in perfect condition; such a piece will ask to be made whole again, particularly if the missing element appears to play a vital part in the rhythm of the silhouette. Once again, each case must be judged on its own merits.

This type of renewal is done in the same material as the piece is executed in, and the restorer will take great care over choosing his wood. This is where, if he is to visualize the missing element as it must have been rather than impose his own style on the repair, he will need to combine the qualities of a first-class art historian with those of a no less competent sculptor.

The new hand or foot or whatever it may be is usually roughed out in a block of wood held in the vice from a plasticine sketch made on the actual statue, with the restorer using the complete wood-carver's tool kit of gouges, chisels, rifflers and rasps. Still incomplete, it is fixed to the statue by the method already described (dowel-pin and Araldite) and finished off there, with the surface being polished or on the contrary roughed up to match the original. It can then be tinted or polychromed if need be.

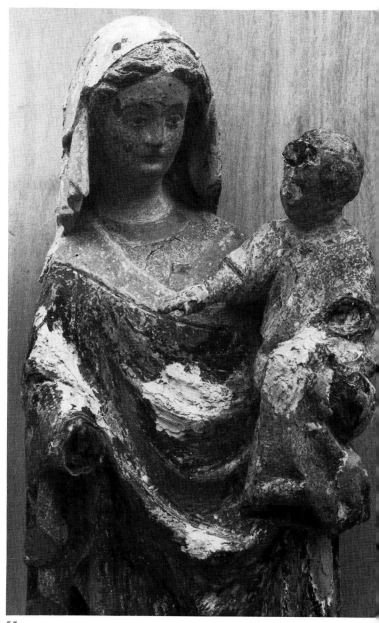

55
The large lacunae from which polychrome and ground are missing are filled with a putty made up of whiting and polyvinyl acetate adhesive.

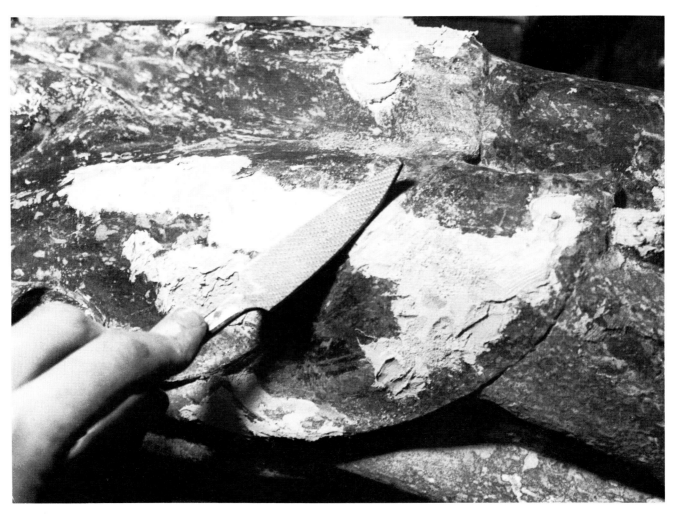

56
When dry, this is worked with a riffler.

Nowadays restoration work by wood sculptors is mainly done on decorative sculpted panelling and furniture, etc. For that type of work technical perfection and real knowledge of various styles are essential (ill. 57).

RETOUCHING RENEWED PORTIONS ON WOODEN SCULPTURE

Retouching stucco or any other material to imitate bare wood is almost as difficult to make a success of as retouching white marble. Polished wood is very slightly transparent at the surface, and the restorer will have to reproduce this transparency if he wants to avoid a "plugged" look. If he feels incapable of retouching to perfect invisibility without painting

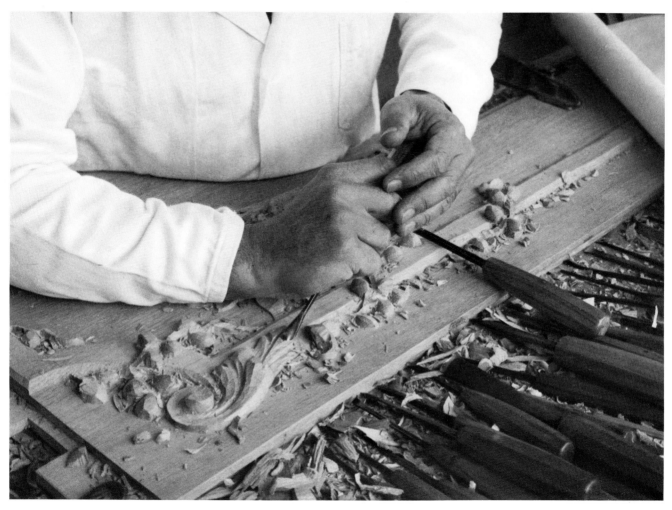

57
A wood-carver completing a piece of Louis XV panelling.

over too much of the original, he had better make do with keeping within the confines of his filling and bringing this up as close as possible to the overall colour.

The filling itself must be very light in colour or even white, no matter what colour the wood. It is this whiteness that, reflecting light through any tints covering it, will give depth and lightness to the restorer's retouching work. The filling is lightly sealed with shellac varnish before one or two transparent glazes are laid over the white surface. These tints should be very slightly lighter than the original wood; a final coat of wax polish will bring them up to exactly the right shade.

But here again we are getting further into the tricks of the trade than verbal description is able to follow, and I can only conclude by recommending a maximum of experimentation with mediums and pigments in the context of this one absolute law: a transparent tint on a light ground.

RETOUCHING POLYCHROME

The saving of the restorer is when the original is polychromed (ill. 58). Polychrome work is sometimes difficult but invariably fascinating to imitate.

The restorer first analyses it closely in order to identify the different tints that go to make it up: wood colour, ground, original polychrome, residual overpaint, patina. He must estimate the thickness of each layer, establish their order of appearance, and note the shape of the flakes of paint. This is already more than half the job; from now on the restorer need only master a few tricks to bring off an excellent piece of retouching.

He begins by recreating approximately the colour of the bare wood, where this is exposed. The next step is to apply a little ground made of glue and tinted whiting. This can be rubbed down and given a slight gloss with wax or shellac varnish. Now comes the polychrome, which the restorer will execute in a shade very slightly lighter than the original paintwork, bringing it up to the right level with a coat of wax polish. The polychrome is put on with a spatula or brush, as the case may be, and if the restorer has used his polyvinyl acetate medium sparingly the paint layer can be flaked in a random and very natural-looking fashion by applying sticky tape and then ripping it off. A light polish with wax will complete the job.

About that final polish. Antique shops contain too many wooden statues that are all glossy with wax. A well-maintained gloss effectively camouflages repairs and mediocrity but is not always in particularly good taste. Ideally the restored piece, whether bare or polychromed, should give an impression of freshness and naturalness, which the restorer achieves by "signing off" with an infinitesimal coat of polish picked up with a soft brush from a cake of dry wax.

Gilded wooden statues

We could have discussed the restoration of gilded wooden statuary in connection with polychrome work. Often on medieval sculpture gold can be regarded as a colour like any other. On Flemish altar-pieces the clothing is gilded with the flesh areas bistre and with a few colours to relieve the mass of gold. But the stripping, cleaning and restoration of a gilded wooden statue call for a special technique that really needs to be considered separately.

The gilder-restorer must have one approach to a piece of carved and gilded furniture (console-table, panelling, picture frame) and quite another to a gilded statue, altar-piece figure, Mechelen *Virgin*, and so on. A French Regency console is certainly prized for the beauty of its gilding but even more for

58
Retouching polychrome work.
a) Holes from which ground is missing are filled in a light colour and rubbed down.
b) Observation has shown that the ground is yellow.
c) The colour is then added, light and transparent.
d) Part of the retouching is now complete.

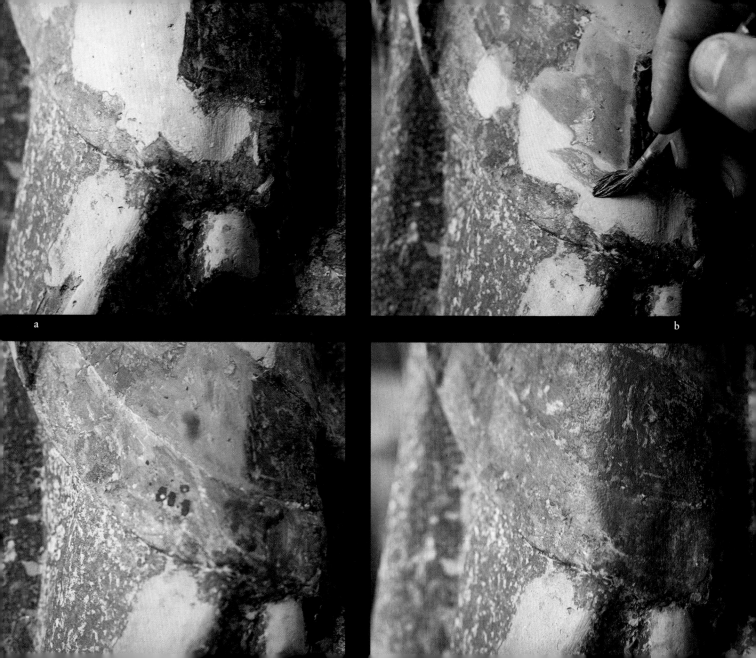

a

b

its richness of conception and design and the extravagant luxury to which it gives expression. Beyond a certain degree of disrepair it loses its point, as it were. The gilder will do what he can to consolidate and retain as much of the old gilding as possible, but once that degree of disrepair has been reached he will remove the lot with warm water and start again, using a process that has remained unchanged since the fifteenth century. He will be judged by the strength of his regilding rather than by his skill and taste in imitating the patina of age on new gold.

On the other hand no one today would allow the kind of complete renewal job that was carried out on the altar-pieces of Jacques de Baerze in 1906 when, having lost their gilding, they were regilded so impeccably as to appear to have been treated by electrolysis.

The gilding on a delicate Mechelen *Virgin* or on an altar-piece will be cleaned, consolidated, possibly completed if only a little is missing, but accepted with large areas of bare wood if the proportion of original gilding left is so small that a complete restoration job would alter the character of the piece. With all his knowledge and in spite of the fact that the technique is unchanged, the modern gilder will never manage to produce, over a large surface, a perfect imitation of the greyish softness of gold dust mingled with the luminous tints of the red-chalk bed that characterizes a Flemish altar-piece. Today, as I keep saying, we have learned to accept and even to love the ruined state of much ancient art.

This is not the place to discuss the restoration of the Regency console I mentioned. However elaborately carved, a table is still a piece of furniture. Besides, this would involve writing a handbook of gilding on wood because – and this is sufficiently unusual to be worth mentioning – the techniques of restoration are the same as those used in manufacture. Here I want to stick to the conservation and restoration of wooden statues that were originally gilded instead of polychromed.

STRIPPING GILDED STATUES

Very often, faced with worn or flaky gilding on a wooden statue, the amateur restorer saw fit to touch up the damaged areas and camouflage any lacunae with liberal applications of "gold paint", which of course contains only powdered bronze. The bronze has since oxidized and gone black, and the piece now has a clumsy and altogether inauthentic look. The only merit of this kind of restoration – and some would say it was a great one – is to provide the restorer who has a "thing" about authenticity with some lovely surprises at little cost in terms of time and effort.

The size and the red-chalk bed that serve as the support for the gold leaf consist of minerals agglomerated with animal glue. Paint stripper will not touch them, so one need not dither between dry stripping and using a chemical stripper. Stripper can be applied liberally, and when it is removed with cotton-wool swabs after having done its work it will take with it all the overpaint, leaving the gold leaf unimpaired (quite the contrary: it will look resurrected). The manufacturers of paint stripper often recommend thorough rinsing, but in this case it is

59
Consolidating the ground on a gilded figure of a carved altar-piece. One can only do this in places where it has already come away. A solution of polyvinyl acetate adhesive and water is made to seep in beneath the ground.

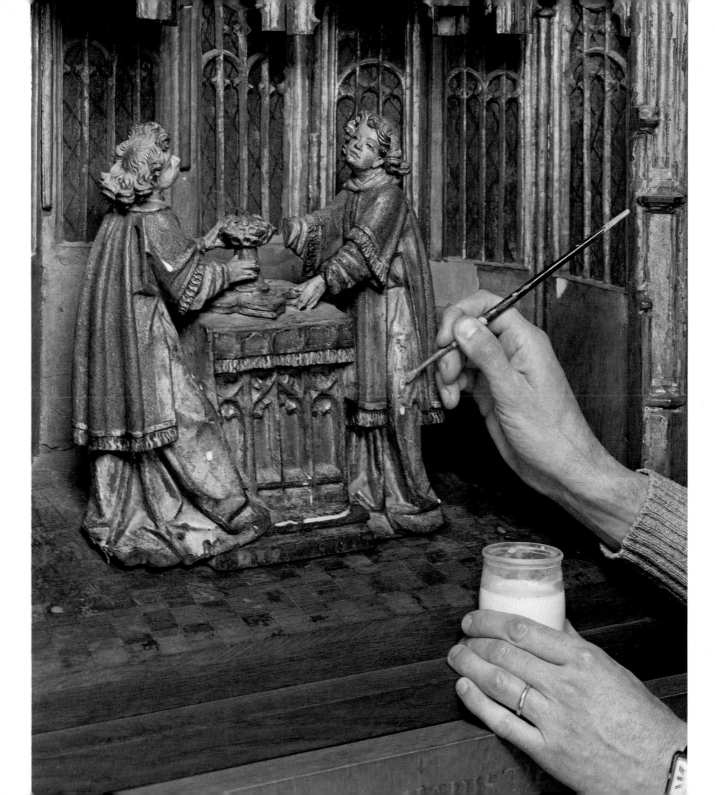

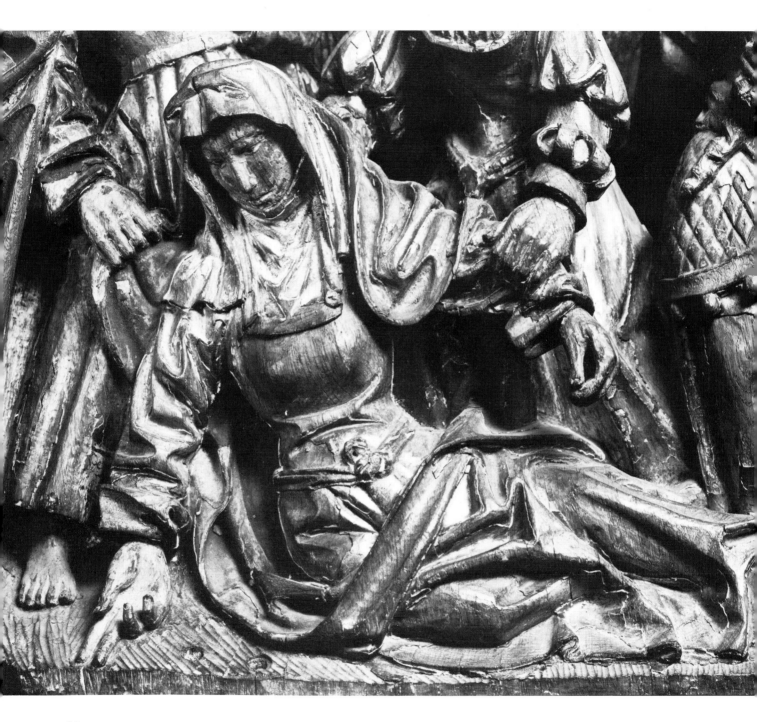

best not to follow their advice; the gold leaf would never stand up to it.

The stripping process will of course uncover the lacunae that were the reason why the bronze was applied in the first place. It will be a bit difficult getting the unwanted material out of these depressions, but a good way is to scrub them gently with stripper and a small, hard brush. The damage revealed is in fact never as serious as one expects; what was found offensive a century ago we find quite acceptable today.

CLEANING GOLD LEAF

Not all gilded statues have been touched up with paint; some simply need to be rid of the quantities of grime coating them. A method that has given satisfaction for years is to use a sort of emulsion consisting of one third oil of turpentine, one third water, and one third linseed-oil, to which must be added a dash of alkali per litre. These ingredients mix no better than oil and vinegar, and the restorer will need to shake the mixture thoroughly before dipping his cotton-wool swab in it. Gold leaf being extremely thin, by the way, it is best not to press too hard with the swab or go over the same place too many times.

CONSOLIDATING THE GROUND

Whereas wood has a tendency to shrink with age its "garment" of red chalk, glue and gold leaf remains

60
Too much gold was missing here for full restoration not to risk altering the character of the piece. The restorer has confined himself to consolidating what was left and making the bare wood harmonize with it.

the same size, often as a result becoming too big for the piece it clothes. If you add to this the fact that eventually the glue loses its power of adhesion, you will appreciate why so much gilding has disappeared or needs very little inducement to do so.

The thinnest grounds usually turn out to be the strongest, being better able to follow the movements of the wood. The altar-pieces by Jacques de Baerze in the Dijon museum illustrate this very well; the portions that were heavily regilded in 1906 have stood up less well than the series of statuettes that still have their fifteenth-century gilding.

The problem here is the same as the one we encountered in connection with consolidating polychrome work (ill. 59), namely that one can only get between the ground and the wood where flaking has already begun; where the gilding is still – for the time being – intact nothing can be done, so that any consolidation can never be more than partial. Again the best method is to mix up some polyvinyl acetate adhesive with warm water and a little absorptive, allowing this to seep in underneath the flaking portions. The water softens the ground and, if this has actually come away from the wood, pressing it down gently with a finger will make it readhere. If it has not come away and still sits well on the wood, though without adhesion, it is better to use Araldite dissolved in trichlorethylene. Being a more absorptive solvent than water, trichlorethylene will seep further in.

Really serious separation between ground and wood may occur when a piece, having been kept in a damp climate for a long time, is moved to a dry climate. This was the case with a large Flemish altar-piece that had already lost fifty per cent of its gold; a further ten per cent was lost during

61
The principal tools and materials required for the execution and repair of gilding on wood: gold cushion, knife, gilder's tip, book of gold leaf and one sheet, powdered gold, ground or bed, agate burnisher.

dismantling and removal to the studio. The attempt to save the remaining forty per cent involved risking the loss of that too. This is what was done:

The remaining gold leaf was shellac-varnished to give it some insulation against water, and the sections of the altar-piece, consisting of groups of three or four figures, were immersed for several minutes in a warm polyvinyl acetate solution (one part adhesive to three parts warm water, with absorptive added). This was done in a sealed tank in which it was possible to induce a partial vacuum, drawing the adhesive deep into the space between what was left of the ground and the surface of the wood. The operation had to be carried out very swiftly in order to keep the immersion time to the minimum; in fact, despite its protective coat of varnish, when the sections were taken out, the ground was found to have been on the point of dissolving into a viscid mass. Each group was carefully cleaned to remove excess adhesive, and when they were dry the varnish was

washed off with alcohol. It is ten years since then, and we are now in a position to say that this "last-ditch" operation was a success.

RESTORING
GILDED WOODEN STATUES

Quick method

When a piece of gilded sculpture or furniture has lost a certain area of ground, the unity of the work is shattered by the white patches offered by the wounds. Or it may be that the areas of bare wood are badly soiled and for that reason form a sad contrast with the remaining gold.

If the restorer does not wish to renew – and renewal, as I have already pointed out, can be a mistake when there is too little of the original gilding left on a high-quality piece – he can carry out what I have called a "quick" restoration job, which consists in simply making the lacunae harmonize with the original gold left around them (ill. 60). This type of restoration has the triple merit of not covering up authentic material, not preventing a more thorough re-restoration at some time in the future, and producing results that are out of all proportion to the effort involved. Indeed, it is astonishing how effectively the white areas on old gilding can be camouflaged with a light water-colour tint. A natural umber, a yellow ochre, a brush, and some water – and the white patches disappear as if by magic and the statue recovers its unity.

On the badly-damaged altar-piece I was talking about it was the wood that was exposed and not the bottom layers of the ground. This had darkened, but a wash in salts of sorrel (oxalic acid) gave it back its pale-brown colour, which then harmonized perfectly with what was left of the gilding.

Complete method

I am talking here about making good limited damage to a valuable piece of sculpture. Having first consolidated the rest of the ground, the restorer mixes a paste consisting of whiting and a high proportion of animal-skin glue. This is brushed into the places where the gilding has come away and left to dry. He then makes up a putty with the same ingredients but using less glue. There is a simple test for verifying the proportions of water, glue and whiting. The restorer takes the putty in his hands and works it into a sausage, allowing this to drop by its own weight until stopped by the work-bench. It must neither stick to his hands nor break. If it sticks to his hands it contains too much glue; if it breaks it contains too little. The putty can be kept in a damp cloth for a maximum of forty-eight hours.

The restorer next uses a steel spatula to force this putty into the holes from which ground and gilding are missing, making sure he does not cover too much of the still-intact portion. Once dry, this second layer is rubbed down with sandpaper or a horsetail stalk. Great care must be taken not to damage the original gilding around the lacuna. The filling is waterproofed with a light shellac varnish. The next stage is to apply the bed. This is what gives the red colour so noticeable on worn gilt work. A layer of crushed red chalk applied with glue provides the support for the gilding, makes it possible to burnish the leaf, and gives this a certain colour by effect of transparency. Today it is impossible to get hold of anything but a heavy, chestnut-coloured chalk, which has to be modified with coloured pig-

ments to make it match the luminous beds used up until the nineteenth century.

The chalk is finely pulverized on a glass palette before being mixed with water and warm animal-skin glue. The mixture is then brushed thinly onto the damaged areas. It is a good idea to give the dry filling a very light rub-down with the finest glass-paper available in order to get rid of any remaining unevenness. Preliminary burnishing with an agate burnisher will give the bed the requisite gloss and transparency.

Now comes the gold (ill. 61). If he is working on a piece where the gilding is still pretty intact, with the red showing through only on a few protruberances, the restorer will use gold leaf.

A sheet (twenty-three grammes per thousand sheets) of yellow gold leaf is placed on the cushion and a piece slightly larger than the area to be regilded is cut out on the leather with a perfectly grease-free knife. The piece of leaf is picked up with the aid of a tip or gilder's brush that the restorer has made slightly sticky by running it over the skin of his face. The area to be regilded is then dampened with another special brush and the piece of leaf applied with a steady hand. When all the pieces are in place and dry, the restorer goes over them again with the burnisher.

This done, it will be very surprising if the renewed portions do not stand out in violent contrast to the original portions. The remedy here is wear first, patinate afterwards. The renewed portion is worn to match the old gold around it with a small cotton-wool swab containing a bit of fine-gauge steel wool or powdered pumice. The object of the patina is on the one hand to correct the colour of the new gold and on the other hand to imitate the stains that the piece has accumulated with age. Some restorers use gouache, others very thin oil-paint. My tip here, as for all kinds of retouching work, is to use powdered pigments mixed with polyvinyl acetate adhesive. The resultant tints, transparent when used pure, can be mixed with a little whiting to imitate the slightly cloudy effect that tarnishes old gold. They can either be brushed on in the usual way or, as often happens, applied in a fine spray, using a stiff brush in the technique known as spatter-work. Nor should the restorer spurn the services of dust, a material that will be in plentiful supply in any restoring studio. Applied dry or on a thin coat of adhesive, it can be extremely useful and effective. Very often, though, the piece to be restored has no more than a vestige of its original gilding. A blend of dust, the red-chalk bed, and even the ivory-coloured ground showing through in places gives it a quality and charm that new gold, even artificially worn, can never imitate. In this case the best thing is to use powdered gold. It burnishes less well and can never produce the metallic lustre of gold leaf, but when applied in a haze, mixed perhaps with powder colour and fixed with a drop of rubber varnish, it gives the effect of very old gilding directly, without using the roundabout method of artificially ageing new material. Using this method, it is also easy to respect the surrounding authentic portion.

TERRACOTTA AND PLASTER

One can grow very fond of a piece of sculpture done in plaster or terracotta. The most boring funerary monument by Falguière or Carrier-Belleuse has in the rapidly executed sketch state qualities of strength and construction that disappear when the work is transferred to stone. The modern age likes what is sketchy; perhaps it is our rationalism that leads us to look, in art, more for the mystery of what is incomplete than for cold perfection. We appreciate the feeling a plaster bust or terracotta maquette gives us of being close to the artist. For it embodies in a very real manner his particular way of applying his material and working it while it is still soft.

Terracotta and plaster are what we call poor materials. They have neither the beauty of marble nor the special quality of wood, which means that there is nothing to come between our aesthetic emotion and the artist's genius. When an artist uses terracotta or plaster, it is what he *says* that counts.

Terracottas

There are various terracottas. There is the clay body that, when it was soft, was worked by Clodion in person and then fired; it could never be very big because the artist was of course unable to use a metal armature, which would have melted in the kiln. Then there is the impression made in the sculptor's studio by forcing soft clay into a plaster mould. The impression is almost invariably touched up by the master or one of his apprentices after having been taken from the mould but before drying and being fired, in order to remove the seam marks and also to emphasize the details. It is not always very easy to tell casts from an original. If the work is bulky the cast will be hollow, and it will not be too difficult to decide whether the marks inside were made by thumbs forcing the clay against the sides of the mould. In the case of sketches the problem does not arise; their freedom would make it impossible to take a moulding.

Finally, there are subsequent "editions", which may date from the artist's lifetime or later, and which may vary considerably in quality. Think of all those Clodion nymphs and fauns that were impressed during the nineteenth century, either in the original moulds or in moulds made from casts! Some were made in the pinkish-beige clay of Clodion's time, some in the red clay of a century later, when Carpeaux was France's principal sculptor.

Knowledge of these facts will considerably influence the restorer's approach, particularly as far as cleaning is concerned.

Cleaning a terracotta is a relatively simple, swift and spectacular operation. In fact, the restorer is often tempted to clean as a matter of course. If he does, however, he may be disappointed. Large-scale garden or decorative terracottas, for example, are not always particularly homogeneous in constitution; their colour may be uneven, with ugly, blackish burns in places, and they may have been deliberately painted, so that it would be a mistake to approach them in any systematic way. On the other hand, one has an idea – for which there is some justification – of what a seventeenth- or eighteenth-century terracotta ought to look like (ideally, a

62
This bust of Voltaire has gone completely black. The volumes of the piece are "inside out".

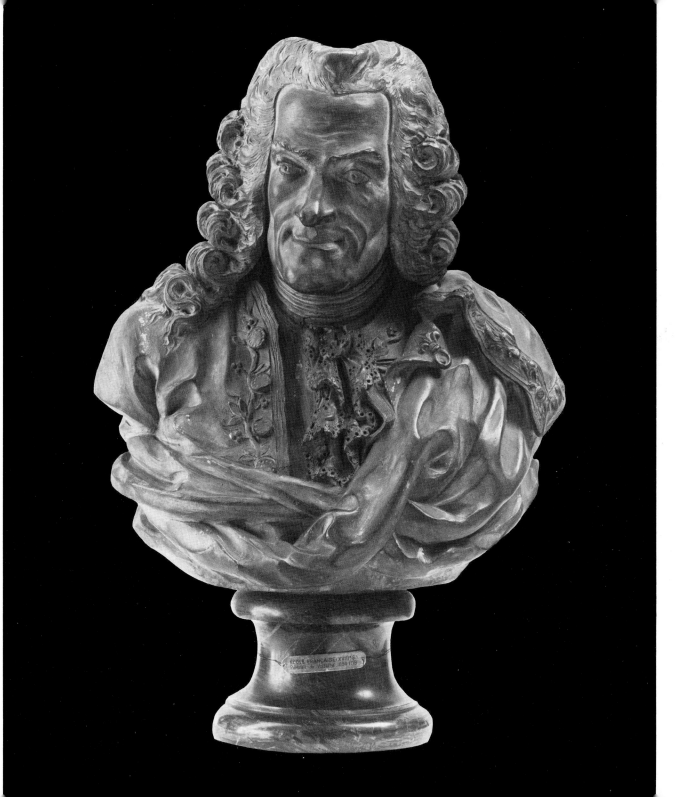

63
The bust is immersed in warm water.

pinkish beige), and if a piece emerges from the cleaning process brick-red it is either nineteenth-century or is going to look embarrassingly like it. A typical example was one of those river allegories of which the owner had high hopes. It was dull, illegible, and thoroughly seventeenth-century, with dirt completely obscuring the colour of the clay. After cleaning, this turned out to be bright orange; the piece had lost all credibility and had to be repainted beige, which made matters worse. So it is often as well to make a spot test before cleaning a piece of terracotta.

Conversely, a major collector of eighteenth-century terracottas, deciding that one of his pieces was so illegible as to be a disgrace to the collection, had it cleaned. The result gave him quite a shock (we shall see in a moment that partial cleaning is impossible on terracotta), but he gradually got used to it, and soon the other pieces looked offensive. So eventually he had his whole collection cleaned, piece by piece, and a great many details came to light, of which he had previously had no idea.

Looked at objectively, what happens when a piece of terracotta or plaster sculpture gets beyond a certain degree of dirtiness? Well, since it is the protuberances that get soiled while the hollows, being sheltered, remain relatively clean, what was meant to be shadow becomes lighter than the now darkened high-lights; the work is turned inside out,

64
The volumes have recovered their true values.

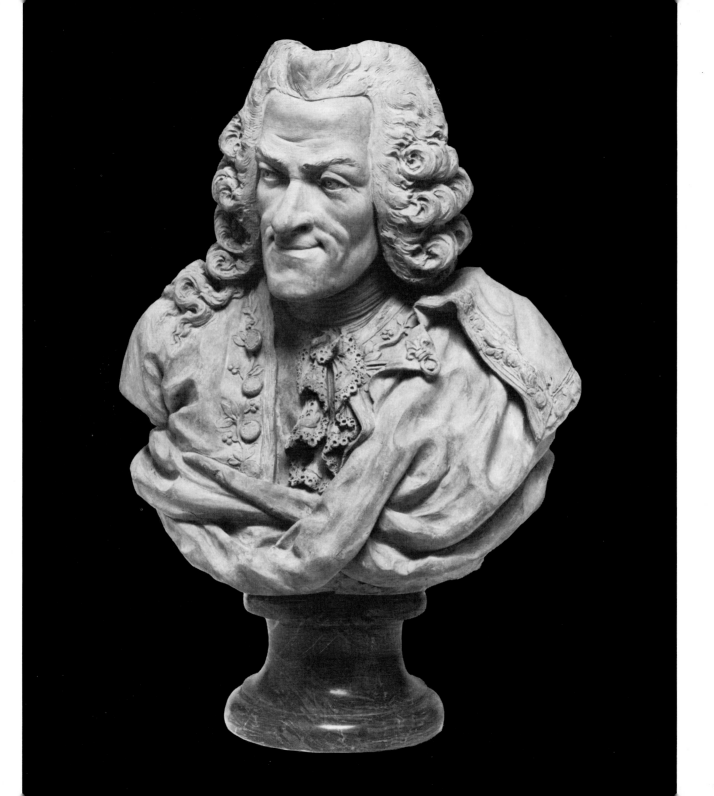

just like a photographic negative, completely falsifying the artist's intention (ill. 62). Yet patina — ninety per cent of which is just common or garden dirt — is regarded as sacrosanct; the most obvious indication of a work's authenticity, it is jealously preserved as an index of social success.

Cleaning a terracotta is usually a very simple process but one that commits the restorer to an unforseeable adventure in so far as it often reveals numerous repairs that either come apart or dissolve and disappear. It is impossible to clean a terracotta partially. The job cannot and must not be done with a cotton-wool swab, soap and water; the dirt will be absorbed in the porous clay and it will be impossible to proceed any further. The piece must first be saturated with water (ill. 63), which means leaving it in a bath overnight. In the morning the restorer will be able to remove the dirt very easily with a stiff brush, using soap and alkali on the stubborn bits. Any glued fragments that fall off are carefully collected, and the piece is allowed to dry thoroughly (ill. 64).

A terracotta that comes too clean can sometimes be repatinated with a water-colour scumble, but I cannot overemphasize how much better it is to let the eye grow accustomed to it and the clay take on a natural patina in the course of time. The occasional piece may look a bit bleached on the high-lights after drying. This can be corrected with a delicate, transparent water-colour tint.

The "all or nothing" character of this cleaning process means that the restorer must be fully aware of what he is likely to achieve. He will not *always* clean. For example, a moderate coating of genuine grime will be left in place, provided that it does not seem to interfere with a proper appreciation of the work of art, and the established restorer will make quite clear to a client when necessary that the cleaning he has ordered will give him a nasty surprise: "Your statue will turn bright red, you'll want me to repaint or repatinate it, and it will look all wrong." He will be tactful enough to give the same advice where he suspects that cleaning will reveal a certain "modern" quality in a work that its owner believes to be eighteenth-century.

REPAIRING TERRACOTTA

Thorough cleaning having exposed all the old repairs — portions renewed in stucco, fragments glued together again, splits caused in the firing or by frost — the restorer proceeds to dry the piece and re-repair it.

The original fragments are carefully rid of any old glue (animal glue dissolves in hot water, shellac in alcohol). They can be reglued easily with Araldite or even, if they are not too large in relation to the fractured area, with polyvinyl acetate. This goes for a chip, a nose, or a piece of drapery; the restorer will use dowel-pins to reattach an arm or leg, just as in the case of larger fragments of stone. The kind of terracotta used for sculpture is rarely very hard and can be drilled with tungsten-carbide bits. Some types are tougher, however, and for these the restorer will have to borrow the lapidary's tube of soft iron turning in a pile of carborundum dust or, better still, one of those trepans with a diamond/bronze crown.

For a very fine mend the restorer makes sure that his polyester does not overflow the holes and uses a film of Araldite to complete the repair (cf. Chapter One, p. 36).

Cracks (ills. 65 and 66), chips and holes are filled in

the same way as on pottery, i.e. small ones with a putty made up of whiting and polyvinyl acetate adhesive, larger ones with one of the polyesters used by marble masons.

In both cases the restorer tries to match the colour of the original terracotta as closely as he can by mixing powdered pigments with his fill. This is applied with a spatula, care being taken to cover as little of the surrounding original as possible. When dry the filling is rubbed down lightly with an abrasive that will not damage the terracotta (ill. 67).

On some original terracottas, particularly certain sketches, the outer skin of the piece presents a highly distinctive appearance characterized by tool or finger marks or by the rather coarse grain of certain types of clay. If the subsequent process of retouching is to be successful, the restorer must try to reproduce these textural peculiarities on the surface of his filling. He can hammer sandpaper onto it, scratch it, mark it with a graver, etc. – imagination will soon suggest the right technique.

On smoother, more delicate types of terracotta the grain is best imitated at the retouching stage by using the appropriate brushwork on a neutrally textured filling.

RENEWING MISSING ELEMENTS

Fingers, hands and arms can be renewed in plastic, stucco, or terracotta. Here we are getting into the higher realms of restoration – and rather a long way from museographical ethics.

In plastic

The restorer starts by fixing a suitable brass armature to the fractured surface. The missing element is then roughly modelled on this armature in tinted,

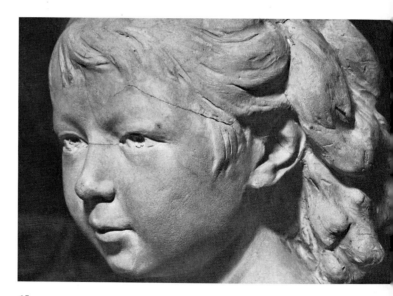

65
This *Little Girl* by Houdon has a firing crack.

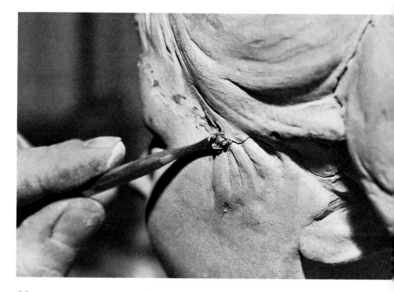

66
The crack is filled with a glue and whiting putty tinted to match the clay.

99

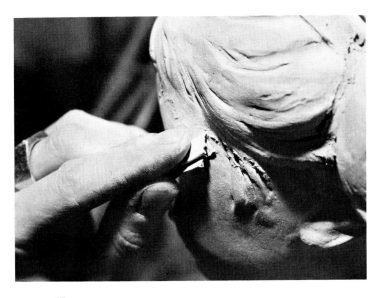

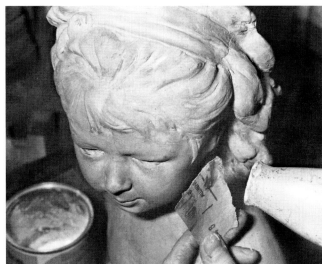

67
The filling is rubbed down when dry.

68
The restorer finds the right colour by testing on a piece of paper.

69
The colour is put on with a polyvinyl acetate adhesive medium. It is too dark now but will lighten as it dries.

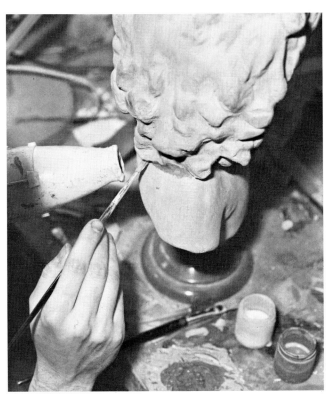

thixotropic polyester. When set, the plastic is worked with rifflers, various graving tools, or steel grinding-wheels on a flexible drive arm. With the kind of plastics used in the marble industry it is always possible to add unpolymerized material to material that has already set.

Carving a hard mass of plastic to imitate an element modelled in clay is extremely tricky work, and it will often be next to impossible to recapture the freedom and life of a rapidly executed sketch.

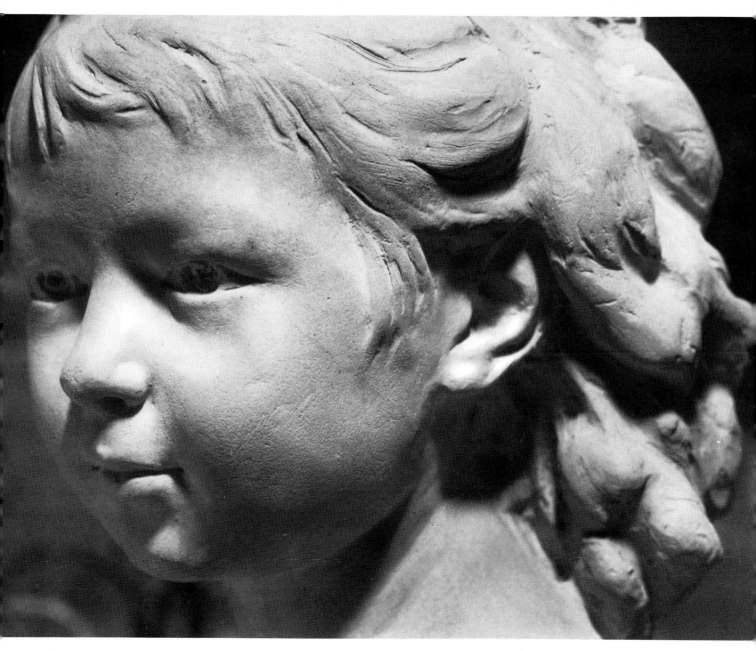

70
The retouched repair is invisible.

In terracotta

It is exceptional for a missing element to be renewed in terracotta. Either the piece is an extremely important one, in which case the restorer will not presume to invent anything he is not sure of, or it is a minor work and plastic or stucco will do just as well.

It may, however, be called for in the restoration of an outdoor ornamental terracotta, where the retouching necessary on plastic or stucco would not survive the first rainy day. There are two main problems here: first, finding a clay of the same colour as the original, and second, the fact that the renewed element will lose a seventh of its volume in drying, so that the restorer will need to make it considerably larger than required. He will also – there are no two ways about it – need to be a very good sculptor indeed.

RETOUCHING

Retouching terracotta is very much like retouching pottery, except that one rarely comes across a piece of pottery as mat and grainy as a terracotta modelled by a sculptor. This is the problem with retouching terracotta – the renewed portion always tends to look too shiny.

The best medium seems to be polyvinyl acetate adhesive, which the restorer blends with pigments and whiting. Depending on the surface to be imitated, the paint is either stroked on with a soft brush or fitched on with a hard one; again, every case is a case apart, and only great adaptability on the restorer's part will keep him out of trouble. Very obvious brush marks may be annoying in one case and just right when it is a question of imitating a surface that has been smoothed off with a finger and a coat of slip (ills. 68–70). The restorer finds and checks his tonal qualities by making the paint dry quickly with an electric hair-dryer. On a terracotta that is not absolutely clean he will lay a lighter tint first, soiling it afterwards with a light water-colour glaze fitched on almost dry. A rub with a dirty hand will give a piece of retouching gloss and patina. Some clays contain grains of mica that gleam softly, a feature that can be reproduced by pulverizing very fine drops of silver powder mixed with shellac varnish.

OUTDOOR TERRACOTTAS

Larger ornamental garden statues – *Venus* figures, infant gardeners, that sort of thing – are often attacked by frost if not taken indoors for the winter. Rain-water that has soaked into the porous clay expands as it freezes and causes exfoliation, turning the piece of sculpture into a very good imitation of puff pastry. There is no treatment effective enough to enable pieces damaged in this way to be placed outside again afterwards. If all that is required is that the piece shall fill an ornamental function indoors, the restorer can try to consolidate it and, if necessary, reconstitute the material that has flaked off and disappeared.

Two methods that can be recommended for solidity combined with a mat finish are brush impregnation with Araldite dissolved in trichlorethylene and immersion in a water solution of polyvinyl acetate adhesive.

Reconstituting terracotta is a tricky business. Where the outer skin of a work is damaged over its whole surface, one will prefer the mystery of a somewhat ill-defined form to the obviously phoney look that reconstituting the surface in some modern material would inevitably produce. In a very few cases of

partial exfoliation of areas that are more exposed than others, the contrast between intact and eroded portions may be seriously prejudicial to one's enjoyment of the work. Here the terracotta will first be thoroughly consolidated and tinted stucco applied, rubbed down when dry and retouched.

Outdoor terracottas are often covered with lichens and dirt. On these, ammonium-fluoride-based products will give as good results as on stone.

Plaster

Plaster in this connection need not necessarily mean a second-rate cast as part of an edition or as a study. The original plasters by Caffieri, J.-B. Lemoyne and Carpeaux illustrate this very well, preserving as they do in a very beautiful ivory tonality the strengths and delicacies of the worked clay. (An original plaster is a cast made from a soft clay model. This is covered with plaster, and when the plaster is dry the clay is removed from inside. This leaves a mould, which is then filled with plaster and broken away. The cast thus obtained is really the primary work and will be used to produce the mould to make the wax casting on the basis of which the sculpture will be transferred to marble.)

On plaster even more than on terracotta, dirt quickly gets beyond the point where it can still be called patina; darkening the high-lights first, it produces that photographic-negative effect that appears to turn the volumes of the piece inside out. Plasters very often need cleaning in order to recover their balance.

Cleaning plaster is as difficult as cleaning terracotta is easy. In fact, sometimes it is downright impos-

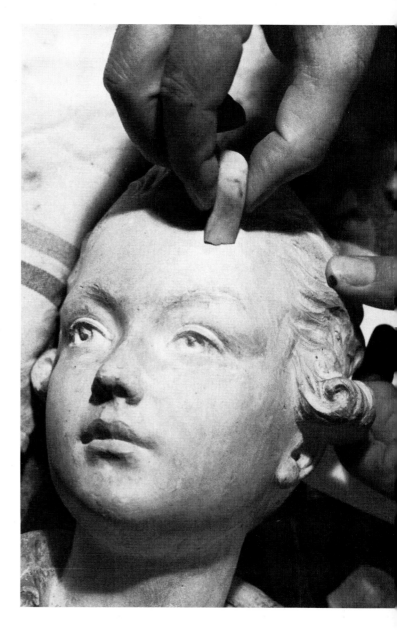

71
Slight soiling may ruin the expression on a face. Sometimes a rub with an eraser will do the trick. The plaster retains its old look but the face recovers its sweetness.

103

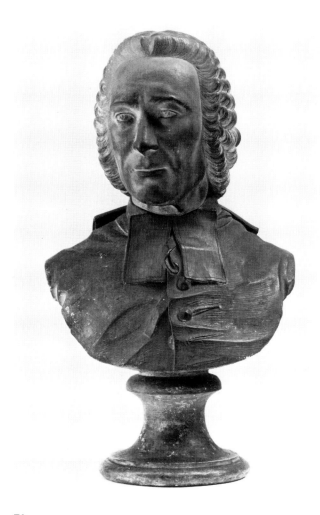

72
This eighteenth-century French portrait bust has been painted and the paint has gone very black. Shadows have replaced the high-lights and vice versa.

sible. Soaking a plaster in water overnight, as we did with terracotta, would produce spectacular enough results. Unfortunately when old plaster is remoistened it becomes covered with quite disastrous golden-yellow stains. So the restorer is obliged to wet the piece as little as possible.

73
The bust is cleaned with chemical paint stripper and a cotton-wool swab. A tool would be dangerous.

74
Shadows and high-lights are now back in the right places. The piece is very yellow from having been washed with water at some time, but its harmony is good.

Another thing the restorer must know about is the skin that forms on plaster – and how fragile it is.

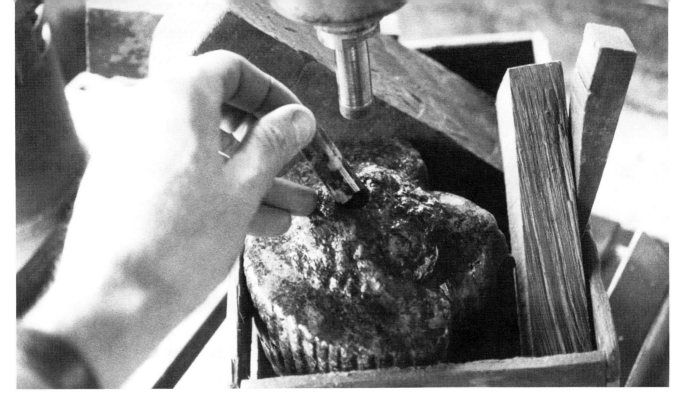

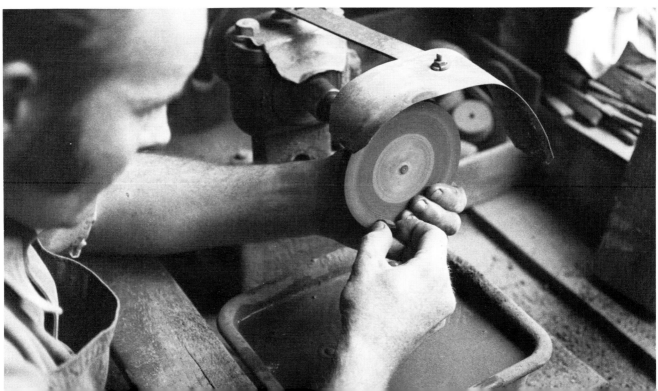

This very thin film that forms on the surface of the work is denser, harder, and less permeable than the body of the plaster. If rubbed too hard, this skin will not only be destroyed but will expose porous, grainy layers that will have neither the same appearance nor the same reaction to future deposits of dust. A plaster that has suffered the ravages of a leaking gutter, for example, will have lost this skin. It will be useless to try and clean it; the dirt will be embedded deep in the plaster, and nothing will remove it.

But assuming the skin is still intact, what can be done to lighten a soiled plaster?

The first step is to dust it very thoroughly with a soft brush and the second to try cleaning it with bread or a charcoal eraser (ill. 71). This may be completely ineffective, however, and it is nearly always necessary to take more vigorous steps.

After numerous trials – some of them successful, some less so – there would seem to be some justification for recommending acetone used in conjunction with ordinary whiting; the plaster is rubbed with a cotton-wool swab moistened with acetone and dipped into a container of whiting.

When he has finished, the restorer will doubtless have to face the fact that, if certain portions have come up beautifully, others are quite unaffected. He will have to step back and look at the work carefully, find some way of restoring its equilibrium, do the minimum amount of retouching necessary to camouflage the dark areas without being tempted to make the ultimate mistake of repainting the whole piece.

Why is plaster so difficult to retouch? On the face of it one would think it was a fairly simple texture to imitate, yet camouflaging a dark patch with an ultra-thin film of adhesive and whiting is an extremely delicate operation. The best method is to brush on light tints and soil them with a water-colour glaze put on almost dry, finishing by lightly waxing the retouched area with a very soft brush. Many plaster busts have been painted at some stage to cover up dirt that proved impossible to remove, yellowing caused by cleaning with too much water, or repairs (ills. 72–4). The restorer will always try to remove such paint. No doubt this will expose the reasons why it was applied in the first place, but quite apart from the fact that what was once thought of as dirt may today go by the name of "patina", the work will gain in delicacy and strength by losing this type of accretion. The restorer will try various solvents such as water, acetone, turpentine, and – if all else fails – a potassium-free paint stripper, always bearing in mind that the surface he is looking for is extremely delicate and vulnerable. Stripper and decomposed paint can apparently be removed quite safely with a pad of fine steel wool.

The key to cleaning plaster sculpture is finding the right balance of light and shade and being prepared to accept a partial result. Harmony and legibility are more important qualities than mere cleanness.

As for repairs, all kinds are possible and are indeed child's play compared with the cleaning and rebalancing process.

75
Drilling a piece of very hard Egyptian granite with a diamond trepan. The core is being removed from the hole.

76
A small hard-stone piece is worked with a carborundum wheel.

Other materials

Apart from wood and stone, sculptors have made use of a host of other materials, ranging from papier mâché to wax and from bronze to Sèvres biscuit-ware. Very often the restorer will be handed a piece of sculpture in a material that is completely new to him. In fact a large part of the fascination of this job is having almost daily to invent a new technique for an unprecedented problem. This constantly inventive approach would no doubt be dangerous if one were restoring paintings or furniture; in the vast and varied realm of sculpture it is indispensable.

HARD STONES

Certain types of stone are in a class by themselves on account of their extreme hardness. It is impossible to work jade, coral, agate, lapis lazuli, porphyry, jasper, and many other semi-precious stones with the sculptor's usual tool kit. Such pieces from China, from the Renaissance period, or from the nineteenth century are sometimes mid-way between jewellery and sculpture; they were carved by lapidaries and will usually have to be repaired by lapidaries, using something harder than the stone concerned.

By and large, all the types of stone that have been used for small-scale sculpture can be worked with the aid of carborundum (silicone carbide). Carborundum is used either in grinding-wheels of various shapes and sizes, working in water, or in powdered form, the grains becoming effective as they embed themselves in various tools made of soft iron (graving tools, fret-saw).

Nowadays diamond tools (soft metals containing powdered industrial diamond) make things very much easier (ill. 75). Any restorer who wants to work with hard stone should equip himself with a tool rather like a dentist's drill (with an electric motor and a flexible drive arm) that will take small carborundum wheels (ill. 76) or indeed the diamond wheels the dentist himself uses. Finding the raw materials with which to renew missing elements is not always easy and will involve patronizing the dealers in minerals who are enjoying such a vogue today. Lapidaries owe their reputations not only to their skill but also to the vast stock of minerals that they hand down from generation to generation and from which they are able to match the rarest jasper from the Naples Treasure.

Between the orthodox method of restoration, which is to renew a missing jade hand with actual jade, and the makeshift solution of camouflaging amputations by rounding off the fracture – and thus altering the piece – there is the middle way of using plastics (polyester, epoxy) to achieve restorations that, though they might give a lapidary fits, look extremely good and have the additional merit of not altering the piece and of being reversible.

After drilling a hole with a diamond trepan, the restorer fixes a brass dowel-pin with Araldite and models the missing element on the pin, using a polyester that he has tinted to match the stone with transparent or opaque colouring agents, as the case may be. The polyester is then worked and polished with grinding-wheel, file and sandpaper. If the original stone is very variegated and opaque it will usually be impossible to imitate in the polyester; the restorer will have to proceed as if he were restoring a piece of porcelain, painting the surface of the renewed element with the right pigments in a polyurethane-varnish medium. Occasionally he may

77
When a bronze has lost its patina, various attractive patinas can be fired on using all kinds of chemicals. Every good founder has his secret recipes.

be able to take advantage of the excellent properties of silicone elastomer to take a moulding of a suitable element on another statue, cast a high-quality reproduction, and simply dowel it in place.

BRONZE
Actually, the restoration of bronze deserves a volume to itself, particularly as regards the superb pieces of work dug up by archaeologists. Like all archaeological finds, these pose special problems with regard to cleaning (getting rid of the matrix of corroded material obscuring their shape), conservation (for many of them continue to deteriorate after being dug up), and restoration (age and corrosion having often reduced them to the fragility of glass). Antique bronzes will be dealt with in a separate volume devoted to the restoration and conservation of archaeological finds. Here we shall confine ourselves to a quick look at the restoration of cast bronzes dating from the Renaissance and later. There are two sorts of problem involved here: on the one hand how to deal with cases of mechanical distortion, and on the other hand how to treat an open-air monument that corrodes on contact with the chlorine in the atmosphere.

Repairing bronze sculpture
A sixteenth-century Italian bronze, for example, has taken a fall, and one arm has been knocked out of position. It can be bent, pushed, or pulled back into

position by any means available (vice, clamp, or joiner's cramp), provided that this does not exert a sudden, violent pressure (like a blow with a hammer) but builds up slowly and steadily. On the other hand, the piece of equipment used must have a gentle enough grip not to damage the object or its patina (lead vice-jaws, rags, wood or cardboard packing).

If the arm has broken off it will have to be re-attached, and here the distortion suffered by the metal before and during breaking may hinder a proper fit. There are two problems to be solved here: First, the poor fit: correcting this will involve tackling the fractured surfaces with a steel grinding-wheel in order to remove any material that is in the way.

Second, there is the general distortion of the whole limb dating from the time of the fracture; even if the arm is refixed perfectly, this distortion will remain. Under no circumstances is it advisable to reheat the metal in order to soften it. The restorer will try to straighten it before refixing or, if this proves impossible, put up with the distortion.

Many great bronze restorers achieve amazing results without either adhesives or welding, using perfectly fitting dowels and blocking-pins and disguising the whole thing with skilful chasing to remesh the metal molecules (matting). My recommendation, however, is to adopt a more modest and at the same time less orthodox approach. This has the merit of not being irreversible and of not affecting the original patina, which on bronzes is extremely important; a fifteenth-century Florentine patina, for example, is not the same as a sixteenth-century Venetian patina, and even less like that on a bronze of the same model cast under Napoleon III.

The severed limb, having been straightened, is re-attached by the same method as we used on stone and wood – two matching holes, a brass pin, and some Araldite warmed to make it set and harden faster. Any remaining holes are filled with a putty made up of rubber varnish and coloured pigments, and the patina is matched up not by treating it with fire and acid but by painting the restored area as if one were dealing with a piece of porcelain, trying to capture the surface transparency of bronze with coats of tinted polyurethane varnish.

If the member is missing altogether and a decision has been taken to renew it, the restorer's first step will be to visit a good art library or museum, where the chances are he will find the original or at least a replica to serve as his model. If an actual model is available, he will take a plaster moulding of the required member; if he only has a photograph he will carve it in wood (lime). In the latter case he will be careful to make it slightly larger than necessary to allow for a casting shrinkage of one seventh. The plaster mould or the block of wood will be given to a bronze founder for lost-wax or sand casting, and the cast obtained will be trimmed and touched up.

The basic patina will be burned on before fixing (ill. 77). When covered with copper nitrate and heated with a blow-lamp, the piece will take on a brown patina; a very fine black patina can be obtained by heating the piece in a fire of oak shavings. Every founder has his patina secrets.

The patinated member is then fixed in place, the scar is filled, and retouching and patinating are completed in paint, with which it is possible to achieve every kind of effect from the transparent gleam of high-lights to the bituminous incrustations on a seventeenth-century Venetian bronze.

78
A tiny eighteenth-century *Madonna and Child* carved in ivory. The missing elements will also be renewed in ivory and worked with a fine grinding-wheel.

Monumental sculpture in bronze

This is causing more and more problems nowadays because the polluted atmosphere of our industrial cities appears to affect bronze very badly. A new bronze used to be left out in the rain for a couple of years to give it a nice natural patina; today statues in cities become covered with pale-green streaks of cupric chloride. Numbers of equestrian statues have been vigorously depatinated, scrubbed down, and then painted in a way that, from a distance, resembles a natural patina. I personally have found that satisfactory and lasting results can be achieved by washing and scrubbing the affected parts with a

brass-wire brush, and rebalancing with a tinted or black marine varnish, which has the merit of protecting the bronze against humidity.

CERAMICS

In addition to vessels and the large terracottas discussed in this volume, potters of all periods have produced small glazed or unglazed ceramic figures modelled in either faience or porcelain. German porcelain manufacturers particularly were famous for their richly decorated, elegantly coloured figures. These delightful works of art are restored in the same way as other objects of porcelain, as described in *The Restorer's Handbook of Ceramics and Glass* in this series. Often a hand or a limb has been knocked off. It can be replaced in synthetic material modelled on a metal armature; the re-

79
Then, using a needle file, the restorer extends the craquelure from the original ivory to the new.

newed portion is then painted to match the original. To work porcelain the restorer will need a set of dentist's diamond drills and polishers.

IVORY

Leaving aside the ivory objects dug up by archaeologists, which pose very special conservation problems, it is not unusual for the restorer to be asked to treat small ivory carvings dating from the Middle Ages or later, some of which may be of very high quality indeed.

Ivory has the same directional properties as wood and may split if subjected to excessive variations in relative humidity. Restoring ivories involves cleaning them, gluing broken bits back on, and above all recarving missing portions. Cleaning is done with soapy water containing a dash of alkali and is usually pretty straightforward, although the restorer will need to work fast in order to avoid letting the piece get too wet. The red or golden patina on old ivory will be unaffected. Refixing is done with Araldite – with or without pinning, as required.

Missing elements can be renewed in ivory (ills. 78–80). For the kind of micro-sculpture involved

80
This restorer is a specialist in restoring ivory. His work consists in carving the fragment to be renewed in a block of ivory and then patinating it to match the original.

here the restorer's tool kit will comprise steel grinding-wheels, needle files, and gravers. The element is roughed out in a small block of ivory held in a hand vice. It is then fixed to the piece with a dowel-pin, finished off *in situ,* and polished with polishing paste. The new piece can be given a patina to match the old with the aid of several coats of potassium permanganate solution. Some restorers, however, think it is impossible to achieve a perfect repair with new ivory and permanganate. They prefer to treat ivory in the same way as Dresden china, renewing any missing portions in synthetic material. Several coats of tinted, translucent polyurethane varnish are sprayed on afterwards to give the right feeling of depth; grain and craquelure are painted on between coats, using very fine brushes. Really skilful restorers can achieve completely invisible repairs, even managing to camouflage the line of fracture or unsightly repairs made by an earlier hand.

WAX

Wax sculptures are few and far between since not many sculptors worked for its own sake a material whose usual fate was to disappear in the founder's mould. One does, however, come across the occa-

81
This statue was repaired by the same tribe as originally executed it. It would be very easy to make an invisible repair, but on this type of object one always respects repairs done by tribal craftsmen.

82
A work by D. Spoerri. A bottle had come unstuck and broken; the restorer is replacing it. Very likely the author of the piece would fail to understand this concern to restore his work, constituting as it does clear proof that society has 'salvaged' him against his will.

sional maquette or portrait dating from the eighteenth or nineteenth century.

Wax tinted dark to model a maquette that will give the look of the final bronze poses no problems beyond that of not softening the work by clumsy restoration. Old wax may dry out, break and crackle. The virgin wax needed to repair it can easily be tinted by mixing it warm with powdered pigments. Wax that is difficult to glue will have to be welded with itself or with other, prepared wax, using a spatula warmed in a flame. Cracks can be filled and missing pieces glued together.

Certain late nineteenth-century portraits were modelled in a transparent yellow wax (incidentally making their subjects look far from well!). These are fairly tricky to restore since there is a danger of virgin wax blackening if the spatula is too hot. Fragments are joined together with wax polish rather than glued. Virgin wax can be softened for modelling by heating it, but this must be done very carefully and calls for the most scrupulous cleanliness.

GLASS PASTE

A few sculptors – e.g. Rodin, Cross and Navarre – experimented with the technique of pouring glass into a mould. Such works are restored in exactly the same way as glass vessels (see *The Restorer's Handbook of Ceramics and Glass*). Gluing is done with Araldite and will never be entirely invisible. Missing material is replaced with polyester, tinted to match the glass.

PRIMITIVE ARTS

Totems, idols and masks from Africa and Oceania often pose a number of problems over and above those normally associated with sculpture in wood.

On the one hand they often comprise elements or materials that may be completely foreign to the restorer's experience. An extra effort of the imagination will be required to reconstitute a raffia hairpiece or to find a naturalist who has the right feather from the right Lake Tanganyika bird or shells from a particular Pacific island. Confronted with such problems as how to consolidate a carapace of dried cow dung without robbing it of its ritual, ephemeral aspect, the restorer will be entitled to feel that he is working at the frontiers of his profession.

On the other hand the restoration of so-called "primitive" objects has its own rather sophisticated rules, and the average collector is a complete perfectionist. The restorer must be capable of repairing a Dan mask in such a way as to leave no trace of his intervention, while at the same time respecting an improvised repair made by a member of the tribe with the aid of a lot of nails and old tin cans. The types of patina occurring on these pieces, which tend to be covered with dried mud, animal blood, or natural resin, are sometimes great fun to imitate. They will call for imagination as well as for the restorer's whole arsenal of glues, earths, varnishes, bitumen, etc. – but they will never be all that difficult to bring off (ill. 81).

SOME PROBLEMS RAISED BY MODERN SCULPTURE

A piece of sculpture need not be old to qualify for the attentions of the restorer – quite the contrary. And I am not being obscurantist with regard to modern art when I say that certain works of non-traditional manufacture are slapdash in terms of technique. I know of one that weighs hundreds of

kilos and is made up entirely of little brass elements badly soldered together with tin. It is impossible to lend the piece for an exhibition without its coming back accompanied by a bag containing some fifty or so of these elements, which then have to be soldered back into place with the aid of a photograph. (Need I add that for every fifty bits that come back in the bag, fifty more have found their way into the dustbin?)

Other works are more in the nature of intellectual manifestoes than pieces of sculpture; the artist meant them to be ephemeral. The French sculptor César did some self-portraits in bread in collaboration with a well-known Parisian baker. They were not without humour, nor was the artist averse to breaking this bread with his disciples; but then the snobs got hold of them, and the restorer had a lot of trouble rescuing them from the twin clutches of rats and mildew.

Experiences such as these with modern works of art make the restorer ask himself what things are coming to. He cannot help thinking that when a Romanesque cathedral burned to the ground it was not restored; they raised a miracle of Gothic architecture in its place. Nowadays the least little utterance of an artist in vogue is carefully preserved and restored, be it executed in marble or in cardboard. Faced with this kind of frenzy of conservation, the restorer sometimes wonders whether it is not a symptom of decadence (ill. 82).

CONCLUSION

The secret of loving something lies in Ariadne's thread. A man may discover the beauty of a statue through looking for the best angle from which to photograph it or the best light in which to do so; he may sense that beauty because of what he knows of the history of art or because he is a sculptor himself and draws inspiration from it. Looked at in this way, restoration would seem to be the thread that leads deepest into the understanding and love of beauty. A piece of sculpture will surrender all its latent qualities to the man who has had it on his work-bench for a week. Someone once said that pastiche was the highest form of literary criticism; the same truth holds for restoration. To retouch a wood-carving is to analyse and appreciate its whole texture – an experience that may communicate tremendous joy. It is impossible to harmonize an eighteenth-century bust by rebalancing shadows and high-lights if one has not grasped the essential spirit of the piece. A hand cannot be reconstituted without involving the overall rhythm of the statue. To clean a polychrome down to its original paintwork is to participate in a gradual discovery of its full loveliness. The imitation of the surface of a piece of stone begins with a caress. And how easily technical problems solve themselves in the wake of this rapport between the work and the restorer! Probably the greatest privilege this job has to offer is to grant one a wonderful, delightful familiarity with man's genius in all its forms.

TECHNICAL NOTES

EQUIPMENT

Studio

A large studio with plenty of daylight, if possible from the north

Work-benches (cabinet-makers' benches will do very well)

Strong trestles

A travelling crane (1 ton)

A travelling platform (about 60 cm. by 60 cm.)

1 turntable 60 cm. high

1 turntable 1.3 m. high

A large fixed sensitive drill

A slipper bath with shower attachment

A sink with hot and cold running water

A grinding-wheel for sharpening tools

For drilling

1 pneumatic drill

1 small impact drill

1 large drill (non-impact)

A set of tungsten-carbide bits from 3 to 30 mm. gauge

A set of trepans from 30 to 70 mm. gauge

A set of high-speed steel bits

An electric motor fitted with a rheostat and a flexible drive arm, plus an assortment of steel and carborundum grinding-wheels

For cleaning

A water spray (and a way of getting rid of the water)

Brass-wire brushes, scrubbing brushes, nail-brushes, tooth-brushes, hard paint-brushes, large round flat-ended brushes

An assortment of basins and buckets

As many glass containers, jam jars, etc. as possible

For stripping

Virtually any tool that will cut or scrape

A flat graver

Spatulas

A scraper made from an old triangular file

A knife made from an old saw blade

Wood carvers' gouges and chisels

Steel wool

Cotton-wool

For fixing

Round brass pins in all sizes from 2 to 50 mm.

Stainless-steel pins

Wooden dowel-pins

Things to hold fragments in place during fixing, e.g. sticky tape, string, cabinet makers' cramps and presses, blocks of wood, rubber bands, clamps, etc.

A metal saw to cut the dowel-pins
A grinding-wheel to make nicks in them
Pieces of plywood or cardboard on which to mix adhesives
Spatulas

For filling
Spatulas in all shapes and sizes (made in the studio out of bits of scrap-iron)
Wooden spatulas
A plasterer's bulb or a small plastic bowl
A large glass palette for mixing putty

For sculpting
(whether to work a filling or renew a missing element)
As large a selection as possible of gouges and chisels for wood
Wood rasps
Dividers and callipers
A set of rifflers
A wire brush for cleaning files
A gradine for plaster
Modelling tools, e.g. spatulas, jointers, etc.
Tools for carving stone, e.g. tungsten-tipped and ordinary chisels, bush-hammer, points, etc.
All kinds of sandpaper from the coarsest to the finest gauges
Hammers and mallets
Metal files
Needle files

For retouching
Frosted-glass palettes (sheets of glass frosted with acid) 6 mm. thick and measuring 24 cm. by 30 cm.

A palette knife and a painting knife
Spatulas
An electric hair-dryer
Brushes:
Stiff hog-bristle brushes
Ordinary paint-brushes with the hairs cropped (very useful for spraying on tiny dots of colour in order to achieve certain effects obtainable in no other way)
Flat brushes in all sizes (sable or polecat-hair)
Fine round brushes (polecat-hair)
A few agate burnishers
A gold cushion, knife, palette and humidifier

MATERIALS

For treatment
Water (de-ionized if possible)
Cellulose compress (Atapulgite)
Xylophène

For cleaning
Soft soap
Alkali
Ammonium fluoride
Detergent
Solvents:
Acetone
Xylene
Trichlorethylene
Oil of turpentine
Paint stripper
Varnishing alcohol
Toluene
Peroxide of hydrogen with alkali
Oxalic acid

For gluing

Cabinet makers' polyvinyl acetate adhesive
Araldite (epoxy resin), slow- and fast-setting
Marble masons' polyester (Syntolit, Akemy)
Cyanoacrylate adhesives
Animal-skin glue

For filling

(or renewing missing elements)
Colourless polyester (as transparent as possible)
Thixotropic polyester
Chemical colourants for polyester
Araldite
Araldite putty
Plastic wood
Whiting
Very fine modelling plaster

For consolidating

Polyurethane varnish and its solvent
Araldite and trichlorethylene
Paraloid and xylene
Polyvinyl acetate adhesive with water and absorptive

For moulding

Moulds:
A silicone elastomer
A thixotropic silicone elastomer
A modelling material that does not break up on contact with elastomers
Plaster

Casts:
Plaster, Araldite, polyester

For retouching

Coloured pigments (earths and refined colours)
Whiting
Titanium dioxide
Water-colours
Bitumen and xylene
Wood colourants (chicory for preference)
Gold leaf and silver leaf
Powdered gold and silver
Plumbago

Varnishes	Solvents
Polyvinyl acetate adhesive	Water
White shellac varnish	Alcohol
Mat shellac varnish	Alcohol
Acrylic picture varnish	Oil of turpentine
Rubber varnish	Xylene
Polyurethane varnish	Special solvent
Virgin wax	Xylene
Slow-setting Araldite	Trichlorethylene

For rubbing-down and polishing

Cakes of polishing paste
Abrasive paper (for dry and wet use)
Rotten-stone
Many of these chemicals are dangerous. Be sure to use with adequate ventilation and do not inhale vapour.

TYPE OF REPAIR ▷ MATERIAL ▽	Cleaning	Stripping	Treatment Disinfection	Consolidation Impregnation
Soft stone	scrubbing plenty of water ammonium fluoride	dry chemical paint stripper	osmosis: soaking in water compress of cellulose putty	vacuum impregnation with resin gamma rays
White marble	soap and water and alkali ammonium fluoride			vacuum impregnation with resin gamma rays
Coloured marble	soap and water and alkali			
Sandstone	soap and water xylene			
Non-polychrome wood	oxalic acid peroxide of hydrogen		gamma rays Xylophène gas chamber	vacuum impregnation with resin gamma rays Paraloid B 72
Polychrome wood	soap and water a dash of alkali	dry chemical paint stripper		by capillary action polyvinyl acetate adhesive and water and absorptive
Gilded wood	emulsion: water and oil of turpentine and linseed-oil	chemical paint stripper		by capillary action polyvinyl acetate adhesive and water and absorptive
Terracotta	soaking in warm water	chemical paint stripper or paint solvent		
Plaster	very little water whiting	chemical paint stripper		
Bronze with patina	dry brushing			
Ivory	a quick wash with soap and water			

Fixing	Filling repairs	Renewing a small missing portion	Renewing a missing element	Retouching
tinted marble masons' polyester	stucco cellulose glaze	stucco	various materials	polyvinyl acetate adhesive water-colour
tinted marble masons' polyester	colourless polyester and colouring agents	colourless polyester and colouring and thixotropic agents	various materials	water-colour polyurethane varnish
tinted marble masons' polyester	tinted polyester	tinted polyester	various materials	done in the filling
tinted marble masons' polyester	tinted polyester	tinted polyester	various materials	rubber varnish
Araldite (epoxy resin)	stucco Araldite putty	stucco Araldite putty	various materials	polyvinyl acetate adhesive wax
	whiting polyvinyl acetate adhesive		various materials	polyvinyl acetate adhesive rubber varnish
			various materials	leaf gilding powdered gold
Araldite or polyester	tinted polyester	tinted polyester	various materials	polyvinyl acetate adhesive
polyvinyl acetate adhesive plaster	whiting and polyvinyl acetate adhesive	plaster	various materials	polyvinyl acetate adhesive
Araldite and dowel-pins (never solder)	Araldite	bronze	various materials	bitumen polyurethane varnish
Araldite	Araldite	ivory or fast-setting Araldite	various materials	patinate new ivory polyurethane varnish

BIBLIOGRAPHY

Abbreviations:

Bull. Inst. r. Patrimoine art
Bulletin de l'Institut Royal du Patrimoine Artistique, Brussels.

Stud. Conservation
Studies in Conservation, London.

ICOM VENICE
Icom, Committee for Conservation, Venice, 1975. Preprints. Paris, 1975.

New York Conference
IIC, New York Conference in the Conservation of Stone and Wooden Objects, 1970. Preprints, 2nd ed., London, 1971.

ABERLE, B. and KOLLER M.: *Konservierung von Holzskulpturen. Probleme und Methoden.* Vienna (Institut für österreichische Kunstforschung des Bundesdenkmalamtes), 1968.

AMBRUSE, W.: "Freeze-drying of Swamp-Degraded Wood" in: *New York Conference.*

ANDRÉ, J.-M.: "Le Raccord" in: *Restauration de la céramique et du verre.* Fribourg, 1976. English transl.: *The Restorer's Handbook of Ceramics and Glass,* trsl. J.A. Underwood. Fribourg, 1976.

ANONYMOUS: "Les maladies de la pierre" in: *Revue de l'Art,* no. 13 (1971), p. 4.

BALLESTREM, A.: "Cleaning of Polychrome Sculpture" in: *New York Conference,* vol. 2, p. 69.

BLETCHLEY, J.D. and FISHER, R.C.: "Use of Gamma Radiation for the Destruction of Woodboring Insects" in: *Nature,* no. 179 (1957), p. 670.

CHAPIRO, A.: *Radiation Chemistry of Polymeric Systems.* London, 1962.

CORNUET, R., RAMIÈRE, R. and TASSIGNY, C. DE: "Application des techniques nucléaires à la conservation des œuvres d'art" in: *Cahier d'information du bureau Eurisotop*, May 1975.

DETANGER, B., RAMIÈRE, R., TASSIGNY, C. DE, EYMERY, R. and NADAILLAC, L. DE: "Application de techniques de polymérisation au traitement des objets en bois". International Conference on Application of Nuclear Methods in the Field of Works of Art, Venice, 24–6 May 1973.

DETANGER, B., RAMIÈRE, R., TASSIGNY, C. DE and EYMERY, R.: "Application des techniques de polymérisation au traitement de la pierre". International Conference on Application of Nuclear Methods in the Field of Works of Art, Venice, 24–6 May 1973.

DOMASLOWSKI, W.: "Consolidation of Stone Objects with Epoxy Resins" in: *Monumentum*, 4 (1969).

DOMASLOWSKI, W.: "L'Affermissement structural des pierres avec des solutions à base de résines époxydes" in: *New York Conference*, vol. 1, p. 85.

GAURI, K.L.: "Improved Impregnation Technique for the Preservation of Stone Statuary" in: *Nature*, 228 (1970), p. 882.

GAURI, K.L., DODERER, G.C., LIPSCOMP, T.N. and SARMA, A.C.: "Reactivity of Treated and Untreated Marble Specimens in an SO_2 Atmosphere" in: *Stud. Conservation*, 18 (1973), p. 25.

HEMPEL, K.F.B.: "Notes on the Conservation of Sculpture, Stone, Marble and Terracotta" in: *Stud. Conservation*, 13 (1968), p. 34.

ICOM VENICE, Group 18: Nuclear Applications to Conservation – 2. R. Ramière and C. de Tassigny 3. E.G. Mavroyannakis 4. E.G. Mavroyannakis 5. Marcel Stefanaggi 6. Jean Taralon 7. Peter Mitanov and Vladimir Kabaivanov.

LEFÈVE, R.: "Altération, protection et consolidation du bois" in: *Bull. Inst. r. Patrimoine art.*, 8 (1965).

LEWIN, S.Z.: "The Preservation of Natural Stone, 1839–1965. An Annotated Bibliography" in: *Art and Archaeology Technical Abstracts*, 6 (1966), no. 1, suppl., pp. 185–272.

MAMILLAN, M.: "L'Altération et la préservation des pierres dans les monuments historiques". Colloque sur l'alteration de la pierre, Brussels, 1966–7, ICOMOS. Paris, 1968.

MAMILLAN, M.: "Pathology of Building Materials". Rome (Centre international pour la conservation et restauration des biens culturels), 1970.

NADAILLAC, L. DE: "Utilisation du rayonnement gamma dans la conservation des biens culturels". Bologna (Centro per la conservazione delle sculture all'aperto), 1972.

NADAILLAC, L. DE: "Contribution au traitement de la pierre". ICOM Committee on Conservation, Madrid, October 1972 (unpublished).

PACKARD, E.: "Consolidation of Decayed Wood Sculpture" in: *New York Conference,* vol. 2, p. 13.

PAQUET, J.P.: "Contribution à l'étude de la maladie de la pierre" in: *Les monuments historiques de la France,* vol. X (1964), pp. 73–88.

PHILIPPOT, P.: "Problèmes esthétiques et archéologiques de conservation des sculptures polychromes" in: *New York Conference,* vol. 2, p. 59.

PLENDERLEITH, H.J.: *The Conservation of Antiquities and Works of Art.* London, New York and Toronto, 1956.

PLENDERLEITH, H.J. and WERNER, A.E.A.: *The Conservation of Antiquities and Works of Art: Treatment, Repair and Conservation.* London, 1972.

PLESTERS, J.: "A Note on Examination of Surface Coatings on Polychrome Sculpture" in: *New York Conference,* vol. 2, p. 137.

ROSSI-MANARESI, R.: "On the Treatment of Stone Sculptures in the Past". Bologna (Centro per la conservazione delle sculture all'aperto), 1972.

SEIFERT, K.: "Die chemische Veränderung der Holzzellwand-Komponenten unter dem Einfluss pflanzlicher und tierischer Schädlinge" in: *Holzforschung. Mitteilungen zur Chemie, Physik, Biologie und Technologie des Holzes,* nos. 3, 4, (1962).

SNEYERS, R. and HENAU P. DE: "La conservation de la pierre" in: *Musées et Monuments,* vol. 11, Paris, 1968.

SYKES, G.: *Disinfection and Sterilisation.* 2nd ed. London, 1956.

TAUBERT, J.: "The Conservation of Wood" in: *New York Conference,* vol. 2, p. 81.

TORRACA, G.: "Traitements préventifs et curatifs des bois de construction contre les altérations biologiques" in: *Cahiers du Centre Technique du Bois,* no. 73, Paris, 1972.

URBANI, G.: *Problemi di conservazione.* Bologna, 1974.

WEIHS, F.: "Über die Restaurierung von Holzbildwerken" in: STRAUB, R.E. (ed.): *Über die Erhaltung von Gemälden und Skulpturen.* Zurich, Stuttgart, 1963, p. 59.

ZYKAN, J.: "Die Konservierung und Restaurierung von Holzplastiken" in: *Artis,* no. 5 (1965), p. 19.

INDEX

We are indebted to the following sources for photographs reproduced in this work: M. CHUZEVILLE: 1. M. ROUTHIER: jacket, 12, 14, 29, 31, 32, 36, 40, 41, 42, 43, 44, 45, 51, 52, 55, 56, 59, 60, 62, 63, 64, 72, 73, 74, 82. M. RÉBY: 10, 11. M. FIÉVET: 5, 6, 7. LE CENTRE D'ÉTUDES NUCLÉAIRES DE GRENOBLE: 48, 49. LA CONSERVATION D'ANGKOR: 19, 22, 33, 34, 35, 39. J.-M. ANDRÉ.

Acknowledgements

I should like to thank warmly all who have helped me by receiving me in their studios or laboratories, or who have shown me their collections and allowed me to photograph works undergoing restoration:
Monsieur Steffanagi and his team at the L.R.M.H.;
Messieurs De Tassigny and Ramière at the Atomic Energy Research Centre (C.E.N.), Grenoble;
Messieurs Barbier, Fancelli, Kolesnikoff, and Pecchioli – sculptors;
Messieurs Chalmin, Mérovil, Michel, Milhou, Péau, and Pédenon – art restorers;
Monsieur Fourrier – lapidary;
And Madame Pierre André, who was brave enough to read through my typescript.

This book was printed by Imprimerie Hertig + Co. S.A., Bienne in June, 1977. Photolithographs by Kreienbühl + Co. S.A., Lucerne. Binding by Burkhardt S.A., Zurich. Layout and production: Ronald Sautebin.